# BONDI
# STYLE

**BONDI STYLE**
Lisa K.Smith

First published 2009.
Wordsmith's Ink Publishing.

**Wordsmith's Ink**

Printed in China.

Aust $39.95
New Zealand $42.95
US & Canada $39.95
UK  £22.99

LISA K. SMITH
PHOTOGRAPHY BY CHRISTOPHER MORRIS

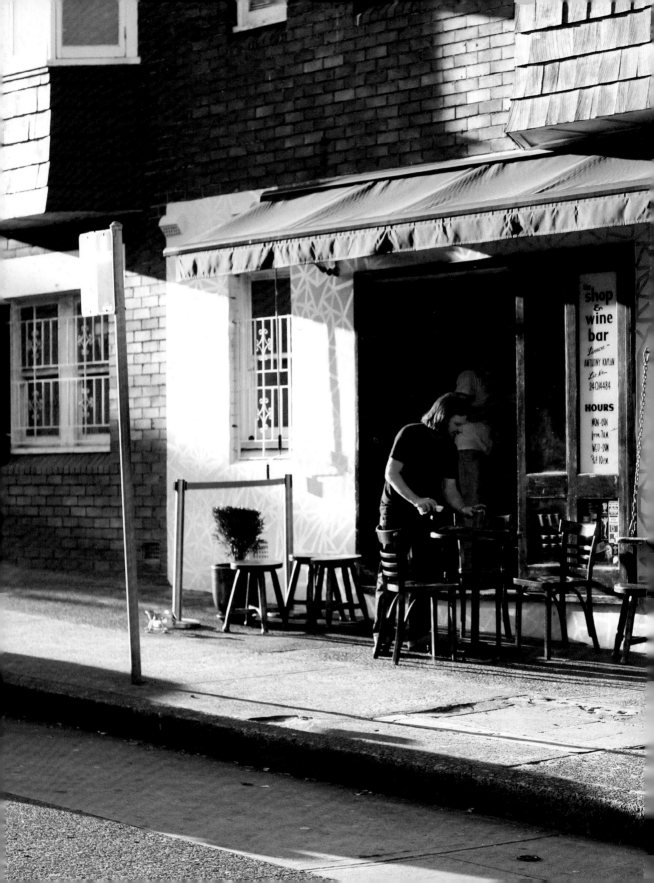

# Bondi is to Sydney what the Marais

EVA GALAMBOS, THIRD GENERATION BONDI RESIDENT.

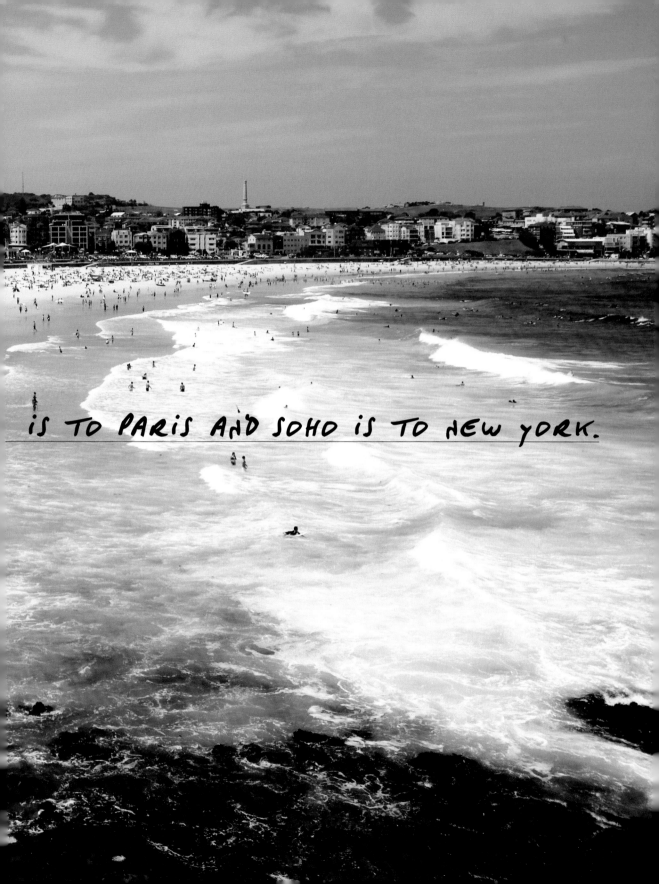

is to PARIS AND SOHO is to NEW YORK.

# B O N D I

# I S AN EXTRAORDINARY PART OF THE WORLD.

It is almost as much of an Australian icon as the Sydney Harbour Bridge or the Opera House, and yet one of the most intriguing, cosmopolitan and bohemian parts of the country.

The beachy environs shape the character of this laid-back hub and its denizens, who are as colourful and varied as the architectural mish-mash lining Bondi's central parade.

Its geographical location – a famous beach located on the doorstep of a large metropolis - makes Bondi part of a small group of its kind, in the company of city beaches in Rio, Cape Town, Miami and Barcelona. It is a diverse, multicultural, ultra-hip place which is home to many of Sydney's most creative and beautiful people. Despite being unashamedly relaxed and informal, one can arguably see there some of the most interesting street fashion in Australia.

If your tourist bus rolled up on the famous Campbell Parade you couldn't mistake the natural beauty of the beach but you would be forgiven for thinking Bondi was distinctly *un*stylish, having driven past unmaintained houses and the daggy coffee shops and garish stores peppering the strip. However, scratch the surface to discover Bondi's charms and be drawn in.

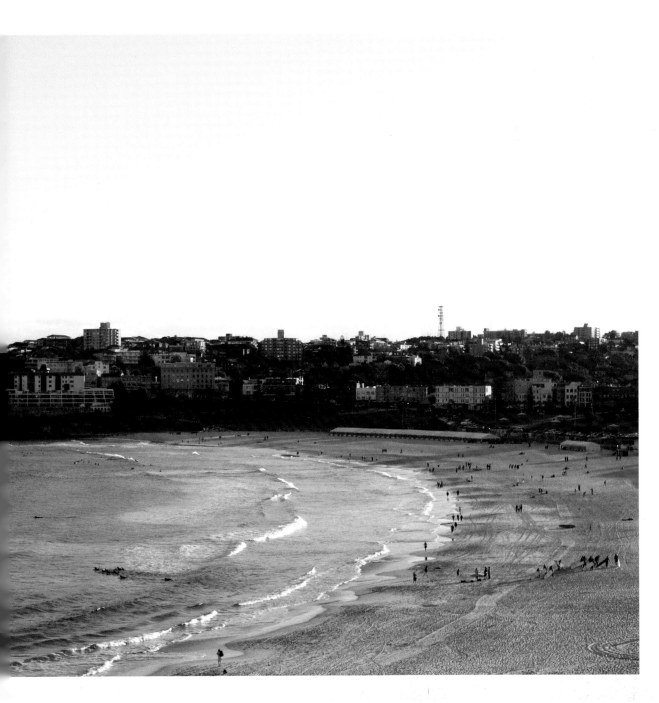

# BONDI STYLE IS

## A SNAPSHOT OF LIFE BEYOND THE TOURIST CLICHÉS

exposing a highly integrated creative community. It features a collection of interviews with well-known local designers, media, restaurateurs, retailers, music artists and other local identities. It presents their views on what makes Bondi such an alluring, eclectic and fashionable place and a glimpse into their personal and working lives.

# CAMERON

26
**PUBLICIST**

I'm wearing a Ksubi feather stole, Nobody shorts, Bensimon shoes, Graz sunglasses, American Apparel braces, Filippa K. tops and jacket, a Cartier ring and necklaces my friend bought me for my birthday.

I'm having my birthday lunch at Icebergs (Dining Room & Bar). You can't go wrong – beautiful view, beautiful food and beautiful people.

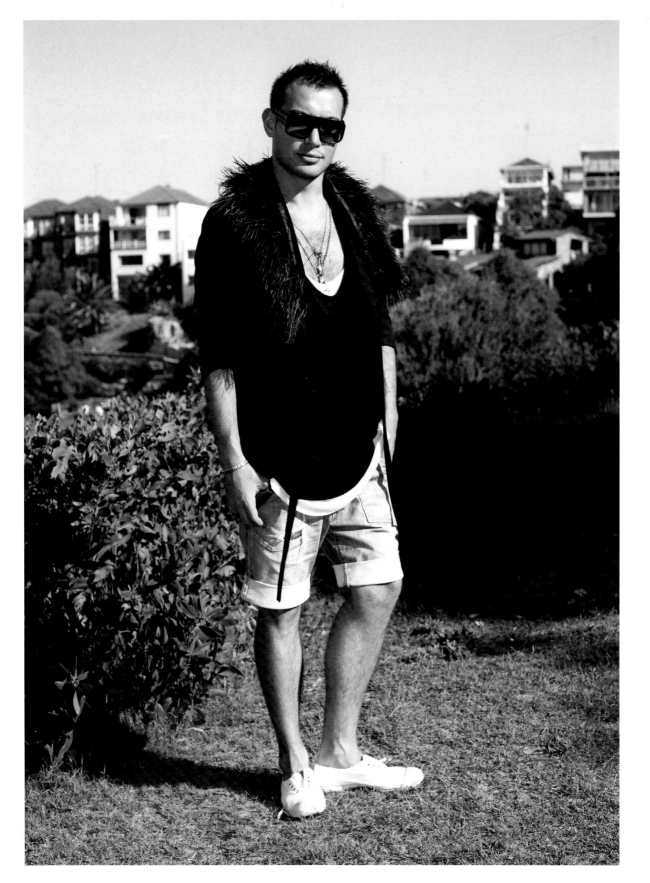

# DAN SINGLE

## DESIGNER, KSUBI

If there is one label synonymous with
Bondi, undoubtedly it is Ksubi. Co-founder
and designer Dan Single is fashion royalty
in Australia and has created of one of
the country's most successful labels and
sub-cultures. Ksubi currently sells in
18 countries internationally with three
Australian concept stores and one in
Soho, New York.

*Dan, you're originally from the Northern
Beaches in Sydney… how is that different
to Bondi?*
It's quieter, the surf's better, life is simpler.

*What brought you to live here?*
Because the hour drive to work every
day is a killer. Two hours in total a day.
That is close to 700 hours a year. That
is 700 hours that could be spent
enjoying myself.

*How has the area evolved over that time?*
There are less bars and the streets
are wider.

*You have Ksubi concept stores and
retailers internationally… what makes
you choose to live in Sydney above
somewhere like New York?*
Because I have a son, Justice. New York
is a single person's town.

*Is your local area a key influence in your
fashion design? If so, how?*
Maybe that it is pretty relaxed and not
too serious.

*How does that look appeal to overseas
customers?*
It appeals because most people seem so
uptight about stuff. We don't really take
ourselves too seriously and I think that is
refreshing for people.

*What awareness or perception do you find
people overseas have of Bondi?*
That it is a beach town filled with actors,
models and photographers (and it's true).

*Your first concept store was in Gould St,
Bondi. Why did you choose this location?*
Because at that time no one was selling
our stuff in Bondi and it is also where we
like to hang out.

*How would you define Bondi style?*
Beachy with a bit of fluoro. Bad
sunglasses and short shorts.

*What changes do you foresee in Bondi
over the next few years?*
Not much I hope. All the hotels will
eventually be gone to make way for
luxury apartments. I hope the whole place
won't be filled with luxury apartments
that nobody can afford to live in.

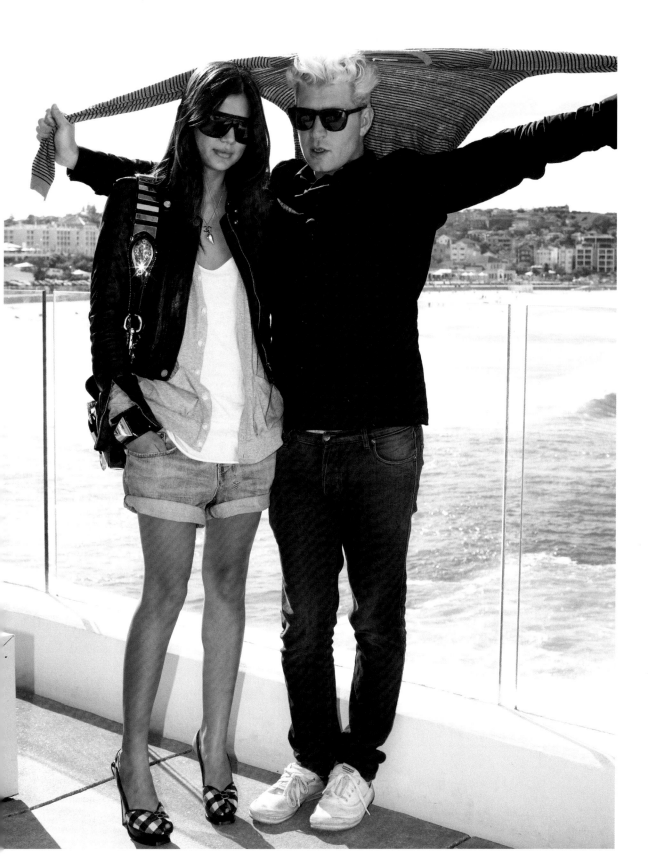

I THINK THE TYPICAL Bondi look is TO 'look' EFFORTLESS,

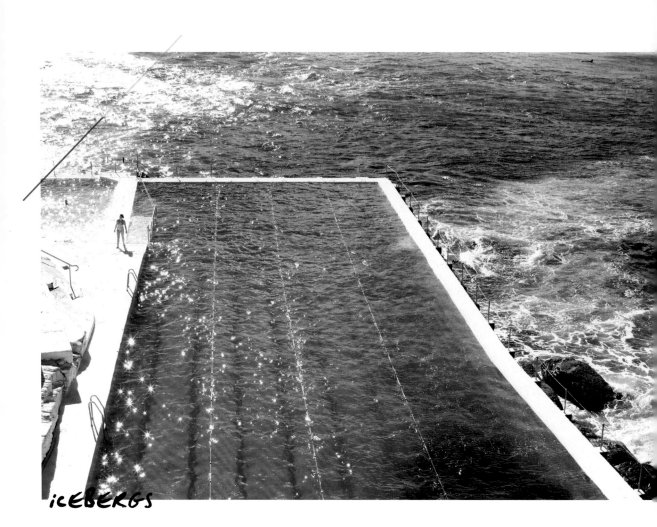

iCEBERGS

# BUT REALLY THERE'S A LOT OF EFFORT GOING ON.

# IF YOU KNOW WHAT I MEAN.

## CHRISTINE CENTENERA

### FASHION EDITOR, HARPER'S BAZAAR

Christine is Fashion Editor for Australian Harper's Bazaar magazine. As one of the country's tastemakers, Christine sheds light on why Bondi is home to so many fashionable and creative types, and how Australian labels figure on the international fashion stage.

*How long have you lived in Bondi?*
Seven years.

*What drew you here?*
The idea of living only 15 minutes from the city/work, but coming home to the beach every day.

*How have you seen it change in that time?*
From a purely aesthetic angle, there are wider streets and newer/renovated buildings. Most have been for the better. I just wish they'd stopped before they thought putting palm trees down Campbell Parade was a good idea.

*Why do you think so many fashion industry people gravitate to Bondi?*
Because we're like sheep. Sheep that like to sunbathe or surf.

*Do you ever use Bondi for shoot locations?*
Yes, I have a few times. I've had to "make it look like LA/Miami/St Tropez/The Greek Islands" too.

*How would you describe Bondi's style?*
Its style revolves around beach living. It's pretty relaxed.

*Is there a typical Bondi look?*
I think the typical Bondi look is to 'look' effortless, but really there's a lot of effort going on. If you know what I mean.

*How diverse are the styles?*
Not overly, being a beach town, but there are a few distinct looks, I guess. There's the 80s-inspired, skinny jeans and t-shirts thing, the vintage ensembles, the people who actually exercise, the people who feel comfortable walking around just in their swimmers, the no shoes thing… there's a lot going on.

*Describe your own look/ style?*
Generally I wear a lot of black, leather, and am always in a heel. Admittedly I look ridiculous walking past Speedo's café to my car each morning. On the weekend I'm much more relaxed.

*Which local designers do you think have had a significant impact on Bondi style or really reflect the Bondi look?*
Ksubi. And not just because Dan's standing here next to me, I swear.

*What do you think are the most influential or well-known local labels internationally? Your personal favourites?*
Some Australian labels definitely stand up on an international level. There's nothing I love more than walking into department stores overseas like Barney's and seeing a rack of Lover clothing next to Marc by Marc Jacobs, Josh Goot in the window of Henri Bendel and Ksubi sitting alongside Rick Owens and Stella McCartney at Maxfield in LA.

*Do you shoot many of these for the magazine?*
All of them; I think it's really important to support Australian fashion.

*Do you hang out in Bondi on the weekend? If so, what's your typical day?*
I rarely leave, mainly because most of my best friends live in Bondi. A typical (summer) day would be spent at the beach, then North Bondi Italian in the afternoon or for dinner, then probably back to a friend's house.

*Favourite things to do in the area?*
I eat at North Bondi Italian at least two to three times a week. I'm a creature of habit and always have the eggplant parmagiana. (It's incredible. Try it.) Plus I love the guys who work there.

I also learnt to surf a couple of summers ago in Byron Bay. I'm still a complete hack, but my friend Zoë and I go out on Sunday afternoons. We get nailed, but we love it.

# DEAN

32

**PROPERTY DEVELOPER**

I'm wearing a D Squared shirt, Nudie jeans, Nike shoes and Rolex watch.

South Bondi is more authentic – more the original Bondi than the North end. Gentrification has brought new people to the area and now there's a lot of wealth in North Bondi.

# JOHN MACARTHUR

## DESIGNER,
## PURL HARBOUR

John Macarthur, one of Bondi's
old-school characters, owns a bespoke
knitwear business. He has crafted
garments that have made their way onto
the cover of Vanity Fair, blockbuster
films and celebrities' wardrobes. His
unique artisanship has endured for nearly
three decades in Bondi.

*When did you come to the area?*
In the mid 80s, but I was doing this (work)
before I came to Bondi. I had a shop in
Gould St before I moved my home here -
I spent most of my life in Bondi but I
hadn't lived here until that time.

*Can you describe broadly what it was
like at that time?*
I thought it was fabulous because it
was very bohemian. It had a great arts
community – writers, artists, poets,
filmmakers, musicians…some successful,
some struggling. There was everyone - blue
collar, white collar, Hungarians, Jews…
rents were affordable then. The thing
everyone was here for was the beach. If it
meant blowing the budget on a great bottle
of wine then they'd do it. People weren't
living their life to be judged by others; they
were living for things they enjoyed.

*What would you say have been the major
changes since then?*
The whole demographic has changed.
When they cleaned up the sewer outlet
the water became pristine. When they
tidied it up the real estate started to rise
then it became fashionable to live here.
In the 90s it started and then it really bit
in around 2000 – paying millions for a
crappy little apartment.

In my early days here, Bondi wasn't so
restauranted out and coffee shopped out.
When I was in Gould St, there was Max's
shoes, the hardware shop and Habibi – a
famous restaurant where you could smoke
pot in the cushioned room. You couldn't get
insurance, it was too dangerous. The Astra
Hotel was rough – it had a real unsavoury
element - drug dealing and general crime.

Back then, Bondi was more kooky and
quirky – it drew artists. Then the money
market people came here with different
values. People were living here for the
kudos of Bondi, not the beach culture.

There was nothing that 'cool' here then.
BBs Wine Bar used to be in Curlewis St.
The Icebergs club was probably the best
club because you had the most amazing
view and you had one big room,. You'd sit
at a table and everyone joined everyone's
table; blue collar, gays, hippies, Jews,
everyone was there – it was really
levelling. Then it changed format; they
tried to make membership exclusive and
the whole thing went.

*What was better about Bondi then;
and now?*
In the 80s it was the boho element; now –
that it's shared by so many people. Even

the backpackers are a colourful addition.
I am just in love with Bondi; it doesn't
matter what changes.

*How and when did you get into your
knitwear label?*
This started in the 90s. I'd been travelling
and doing everything; I was 30 before
I started it. I travelled for six and a half
years; lived in Spain four of those. I'd
always learnt knitting. I grew up in
Bombala, in the Southern Tablelands.
We had no TV; it was cold in winter, so
we used to make things. During the hippy
period when everyone was on acid, I
could walk around knitting and look like
I was on acid without actually having
to do it.

I kept my hand in; when I came back
from overseas I was sick in bed and
decided I'd knit. People saw it and
said I should make for others. I bought
a knitting machine and started at the
Paddington markets. That's when Paddo
wasn't as homogenised as now; it was
quirky and kooky with unique, individual
stores. During the 'Japanese recession
dressing' period the more distended, the
more holes, the more disproportioned, the
better. It was hailed as more avant-garde.
Had the fashion been structured and neat
I would have failed miserably.

*Describe the process of creating your
garments. How long does it take?*
I just finished coats which took six days
to make. Machines will do some but you
can't achieve some things by machine,
only by hand.

*What sort of machinery was used?*
I have domestic knitting machines that
you used to be able to buy in department
stores. It's dying now; you have to go
onto eBay to find them.

*In addition to your Jaques Avenue store,
where can people buy your garments?*
Prior to having the shop, I used to just
wholesale; I had agents in every state.
I was still on domestic machines and
thought I'd try manufacturing quantities.
I employed a mill to do a range every
season, sold all around Australia and some
overseas. Then I got the shop and it went
back to what it originally was. In dealing
with public, how they dress is about their
own stamp.

I had a massive amount of stuff through
the mags – it generated so much interest
and business. It was the beginning of the
'validation' thing; buying it because it
was in magazine.

I do still wholesale to a few stores, or I'll help designers with their knits. I have done some knits for Ksubi, Kirrily Johnston, Wayne Cooper, Easton Pearson and Willow.

*Have any famous people come into the shop or bought from you?*
Kim Basinger over the phone; Cindy Crawford came into the shop; our local celeb market like Kate Ceberano; Julia Roberts and also Keith Richards' wife Patti Hansen. Patti used to come in and hang out – we clicked.

*Do you have a bespoke service?*
There are a couple of dimensions: you can come and buy from the shelf, or if you see something on the shelf that you want to change I can do it. Also, if you have a pic of something I will try to replicate it.

*What have been some highlights of your career?*
I got the cover of Vanity Fair once. A friend who does hair and makeup in New York – an Australian – used to work with Herb Ritts. They were shooting Liam Neeson and my friend Max arrived in one of my sweaters. Liam said "I want that" so they shot him in it. I got Bergdorf's and Bugatti in Soho as a result.

I've worked on a lot of Australian film; with most local films and theatre I get to work on them. Wolverine, Billy Elliot, Superman, Muriel's Wedding – I loved Muriel's for the 'trailer park trash' stuff I made; that's the interesting thing, you go into different eras. For example, in the film Australia I did 1940s pieces.

*What do you see for the future of artisanship such as yours in Australia?*
Sadly I think it will go. One of the main reasons is generations coming through that are wired differently; they want instant gratification. These things which take time just aren't of value anymore. Human deplete, technologically strong.

*Having lasted so long, what would you say has been the secret to longevity in business, especially in a niche business such as yours?*
It is certainly not me – it must be the concept. If it's gone this far with me I can only assume it would've kicked ass

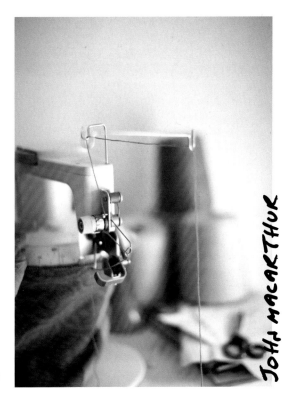

with someone more business-savvy at the helm. It's the only bespoke knit business I know of; maybe that's why.

*Bondi's future -what do you see?*
North Bondi has always been groovy. Tama(rama) took me totally by surprise – what they've done there I never would've thought. Massive LA-style 'leave the price tag on' architecture. I hate it.

I would never have predicted 'this'. I bought a place for $1.50 – I bought here because I loved here; not because it was a smart decision. As long as they don't cement the beach or make it prohibited to go in the ocean, I'll be happy as.

I AM DEFINITELY GOING TO COME BACK FOR

# NO DR
# IS TOC

SOPHIE DREYER MIKKELSEN, TRAVELLER

SUMMER HERE. I LOVE THAT HERE

# E A M

# B I G

# LEAH

25
DESIGN ROOM ASSISTANT

Dress and tights by Sass & Bide. Vintage jewellery from my mum and grandmother; other jewellery pieces from Mexico.

On my typical weekend I wake up and go on a walk or run. My flatmates and I always make lunch together (prawn cocktails today) then do yoga and have glasses of wine at sunset.

# ADRIAN

33
## PHOTOGRAPHER

I'm wearing a leather jacket so old it's almost vintage, an Ansari knit, Lee jeans and my trusty Nike Vandals, sadly now nearly dead.

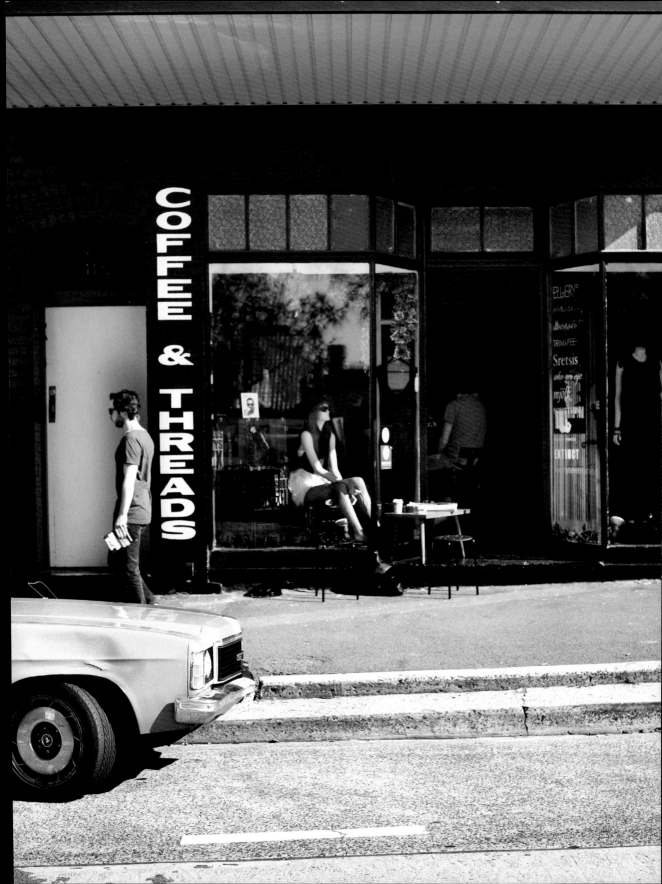

**MILLY**

25

PUBLICIST

I'm wearing a Willow jacket, Converse shoes, YSL bag, Cheap Monday jeans, Ksubi top and the jewellery I've collected over the years. I love jewellery; I haven't had a clear wrist in years. The rings from my Grandma are probably my favourite.

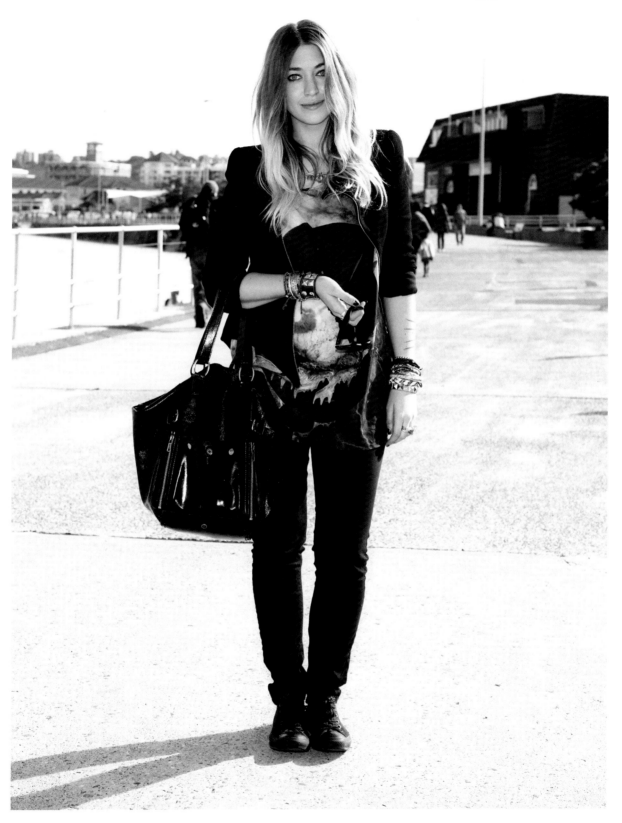

**ALICE**
25
**ART BUYER**

I'm wearing pants from Zara, an American Apparel tee, shoes from Tuchuzy, bag from Bali, Ray-Ban sunglasses, bangles from Thailand, a Fendi bracelet, Mezi ring and cuff from General Pants.

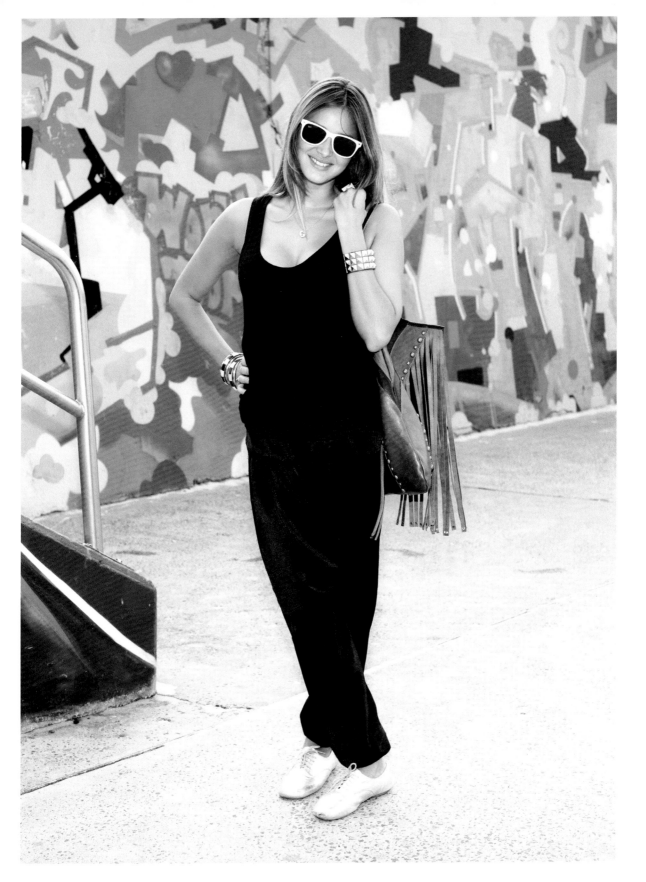

# TALI JATALI

## DESIGNER, JATALI

Tali Jatali is an eccentric and glamorous
retailer and designer. Her long -held
boutique on Bondi's famous Gould St
strip is as quirky as its owner.

*Where are you from? When did you come
to Bondi?*
I came to Bondi many years ago, as my
whole family moved here from Israel.
I was born there to a Romanian mama
and papa who have been married for
49 years - wow.

*How did you get into fashion retail?*
I started the Jatali brand with Jamie
Walsham who owns (label) One
Teaspoon. We went our own way as I
didn't like wholesale at the time, so I
opened my store. Prior to that I sold Jatali
to around 48 stores.

*How long have you had your store in
Bondi?*
Nine years.

*How has the Gould St precinct evolved
over that time?*
There are so many more retail stores here
now; the street's also more renovated.
The high-street shoppers who go to
Oxford St, Paddington, now come to
Gould St as a destination.

BONDI IS THE BEST PLACE EVER

...IT GROWS IN STYLE EVERY YEAR.

**Who are your customers?**

My customers are lots of young girls who party at clubs and want to look hot for the boys. They are also girls who are older, wanting to look unique and not be seen in the same dress when they are out. They know mine are mainly one-offs.

*What look is your store about?*

Young, funky, perfect for day parties or when you break up with your boyfriend and go to a party where you want to make him jealous.

*Do you think this is a typical Bondi look?*

Definitely. It's the casual attitude – but you still want to look cute – there are hot guys everywhere here, you can't look bad.

*Your own style is interesting – where do you shop?*

I shop at lots of markets and gorgeous boutiques; I'm not much into shopping centres as it's too hard to find the car after the event.

*How would you define Bondi style?*

I think it's so fashion-forward; we're setting trends constantly. People here are brave in what they wear; they do what they want. If you're a fashion designer, you could sit across the road from my store and get all your ideas for your collection from watching the people who go past.

*What changes do you foresee in Bondi over the coming years?*

The biggest change I see in Bondi is the shop rents are going to be huge. I think besides that, Bondi is the best place ever as it grows in style every year.

*What labels do you sell?*

Jatali of course, which is mainly amazing and unique one-off dresses that cost too much, but the girls just love them.

For the Jatali label, I get hot vintage one-off t-shirts sent to me from New York every two weeks, which I custom cut and style so you can't get them anywhere else, and I get amazing dresses from London which are one-off and so red-carpet-eat-your-heart-out.

We have a Brazilian label called Totem and my swimwear label called Jatali gets Wet.

The rest is local young, cute designers who I help promote as they are fresh and I like them a lot. Shardie is a label I sell by a young Bondi girl and I also love Simon Deans, an art student who hand prints Kate Moss and Pete Docherty tees.

# KYM ELLERY

### DESIGNER,
### ELLERY

Central St Martins-trained Kym Ellery is personally becoming a local style icon, while her striking, sculptural fashion range carves out a rep as one of Australia's best.

*How did you get into designing?*
As far back as I can remember I've always wanted to design clothing. My mother is an artist and a sewer so my childhood was spent 'creating'. It never wore off.

*When did you start Ellery?*
In the summer of 2007. A stylist at Vogue, Trevor Stones, shot a pair of glitter tights that I had made for one of his main book fashion editorials. The shots were amazing and I thought that if Vogue was shooting my creations before I had even begun a brand, then I should start my label ASAP.

*Describe your label in a few words.*
Chic, sculptural and fashion-forward.

*What's the profile of your typical customer?*
There seems to be a balance between women that just want beautiful, well-made clothing and the fashionistas who must have the most fashion-forward pieces of the season.

*How would you describe your own style?*
It tends to be a mixture of feminine/sexy and tomboy/cool but I would best describe it like a box of chocolates; you never really know what you're going to get.

*Who are your muses?*
My mother and father. And at the moment Jerry Hall circa mid 80s; Mert and Marcus, a Brazilian fashion photography duo – they are amazing and my absolute favourite; Ryan McGinley, also a photographer; Carine Roitfeld, Editor-in-Chief, French Vogue; James Harvey, an Art Director and drummer in band 'Hot Little Hands'; Susie McCallum, PR to the stars and good friend; Ilona Hamer, Vogue Australia and one of my best friends and Kinga Burza, Director based in London and my greatest friend.

*What do we have in store with your upcoming season's range?*
It's a dark take on beauty pageants, my favourite pageant being an 80s 'Miss Teen USA' competition. Amazing.

*How do you think being based in Sydney affects your design sensibility?*
It keeps me inspired by international fashion. This is important because I need there to be a higher level of something to aspire to.

*What are your favourite things to do in Bondi?*
Snuggle up in my lounge room and watch the waves crash against the rocks.

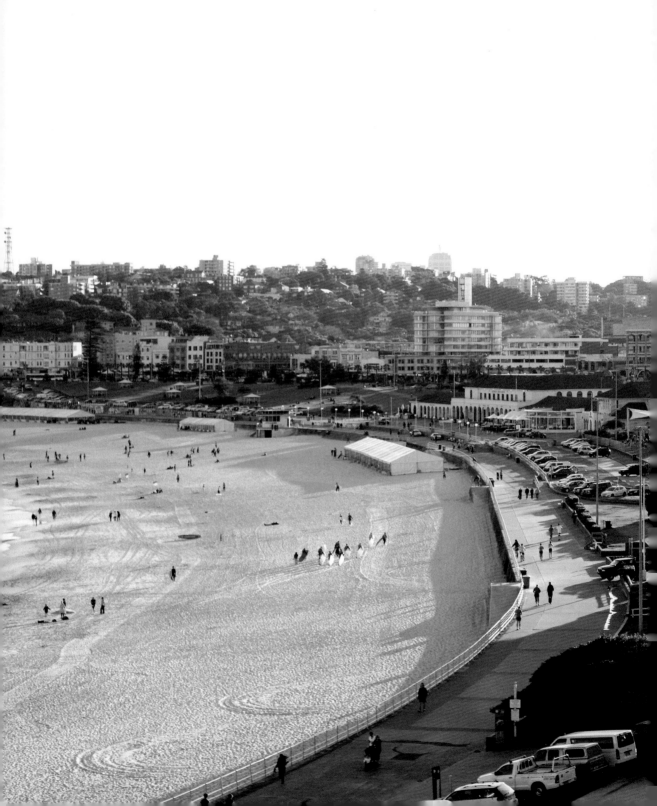

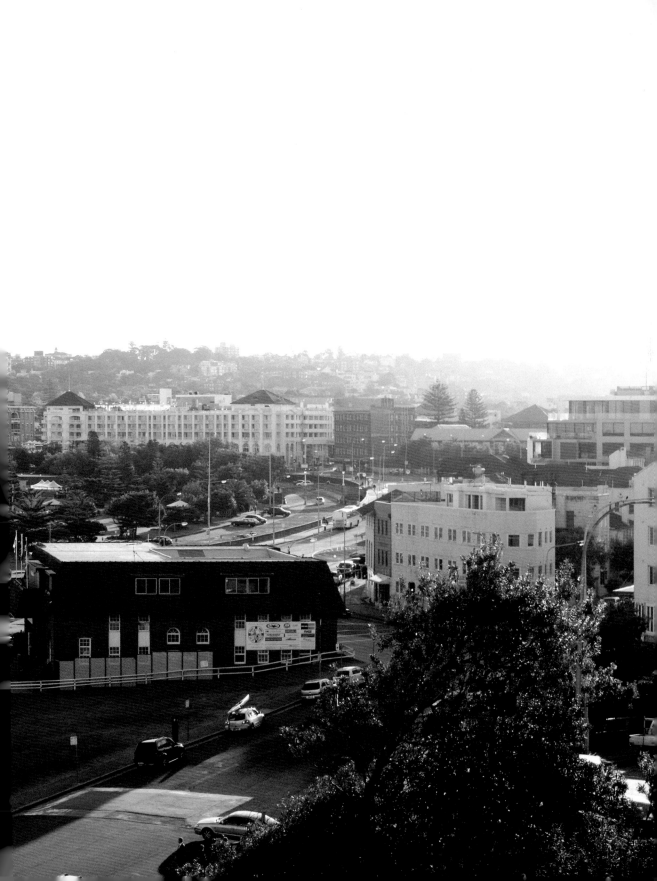

# LOPES

28

**NIGHTCLUB MANAGER**

I'm wearing a leather jacket from Mim's, tee from American Apparel, Nudie jeans, a customised belt from my brother's store in Paris and Diesel shoes.

## CAT

20

MODEL

## STEPH

22

MODEL

Grey Sass & Bide jeans, a Cheap Monday singlet, secondhand jacket from Vinnie's (charity second-hand store), vintage sunglasses, a vintage necklace from Mum and black Havaianas thongs.

I wear a lot of second hand/vintage clothes. I'm influenced by a lot of 60s and 70s clothing and by friends who have a cool style.

Jeans from Cheap Monday, an old top from Sportsgirl, scarf and shoes from The Church (second hand sale), a boy's cardi from General Pants and bags from Vinnie's in Brisbane and Ksubi.

I'm influenced differently all the time by looks I see from overseas, here and movies. I dress androgynously a lot: button up shirts, skinny jeans and lace ups, but love to mix it up. I find my own style when I go shopping at the second hand stores.

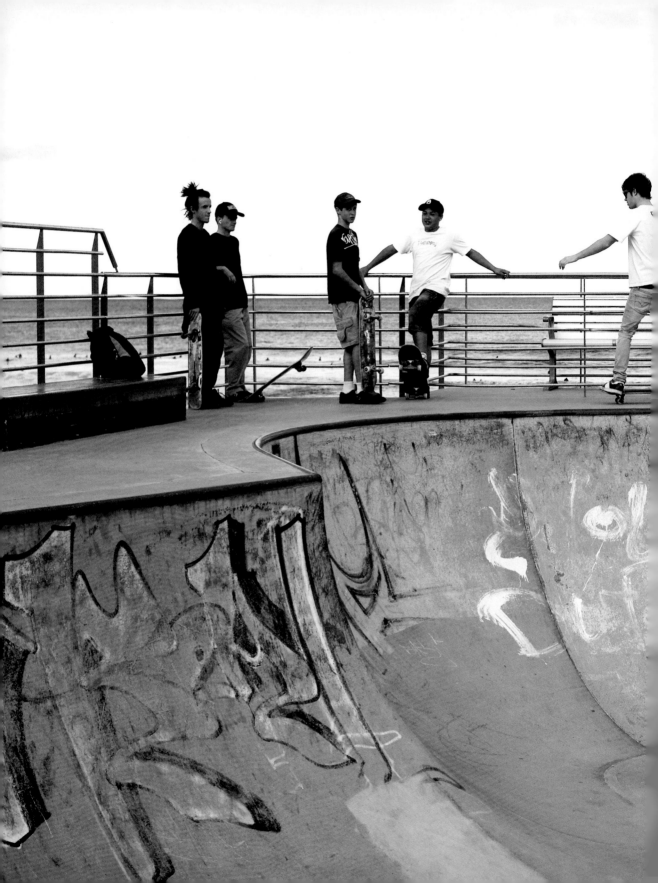

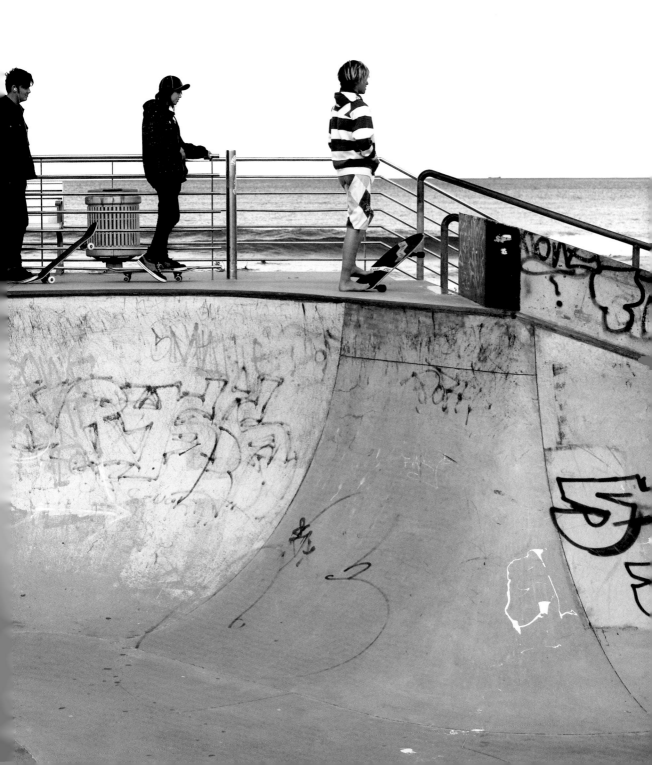

# B O N D I
# I S

GOING OUT TO DINNER IN THE SAM

ANNA HARRISON, WRITER / BUYER

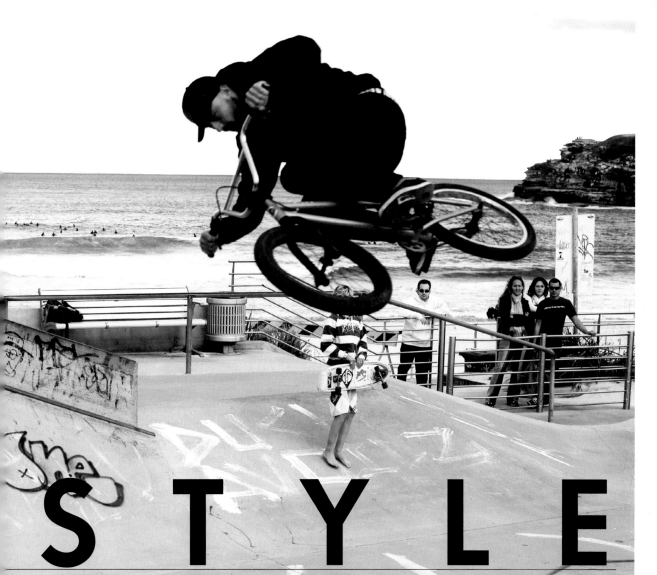

# STYLE

OTHES YOU WOKE UP IN.

# TONY

36

## MUSIC PROMOTER / BOOKER

I'm wearing Obey jeans from Hypnosis Reversal, Rare tee shirt from a mate's closet, Prada sunnies and Havaiana thongs. The relaxed environment we live in here is great…anything goes.

**RICK**

22

**SALES**

I'm wearing a bag featuring the band Mars Volta, vintage Ray Ban sunglasses, RVCA pants, Cotton On top and Marsu Homme boots.

# FERNANDO FRISONI

## DESIGNER AND FASHION COLUMNIST

Brazil-born Fernando Frisoni is an urban style columnist and fashion designer of his eponymous label. Fernando's renowned street fashion reportage page in Sydney's Sun Herald is a barometer of real local style.

*You're from Brazil; what brought you here?*
I'm from São Paulo, Brazil, a very chaotic city…very busy but very alive. I came to Sydney for a holiday in 2000; to watch the Olympics, to be at the beach and relax. I met my partner Sam Rickard then, and we have been together since. He's the main reason I decided to move to Australia.

*Your 'Urban Style' page has become much observed – almost iconic…how did you come up with this concept?*
I created the idea, then I submitted it to the paper and together with the former Features Editor Saska Graville, we developed Urban Style. At the time the social pages were featuring the same people all the time, only at PR events and private functions, so I was reading the paper and seeing the same people over and over.

Urban Style was created to mix social and fashion with a real sense of journalism. The page became a new wave with an impact on our sceptical generation. Urban Style launched in the S section of The Sun Herald five years ago. Since the feature launched, it's become a key forum for communicating street fashion, exposing glam, punk, surf -whatever's creative.

*What makes you select a subject for your column?*
It's something I can't explain; one needs to have an attitude, a personality, a creative look. Attitude is everywhere - the way one walks, talks and looks and especially the way one dresses. My subject needs to have a visual power, an expression. I need to see something more…I love when someone shows an extreme point of difference, one's own personality, not a copy or a trend. I love an individual sense of style, no matter how it looks.

*Do you think there's a typical Bondi look; if so, how would you describe it?*
A Bondi look…I don't like to identify a look or a place…but yes, a good Bondi look would be vintage mirrored sunglasses, oversized shirt on top of the bikini, then thongs and a beach towel.

Bondi is a mix of kitsch, sexy and corny street wear I would say; kind of hippy, a modern hippy. It depends, if you go to the North it is classier and a bit more upmarket - Eastern Suburbs princesses in very nice swimwear and expensive sunglasses. I'd say a mix of Santa Barbara, California with Biarritz in the South of France with a touch of San Sebastian on the Spanish coast. The middle - well the middle is always the middle. The South is a mix of backpackers and visitors from other suburbs. Still pleasant and fantastic; I do love the backpacker look at the beach - it's very Australian; it is an identity that the country will always have.

During the week is different; it's cool, it's friendly, it feels good like a community. There's the sunset with beautiful people running on the soft sand, kids swimming, surfers coming and going from the waves, dogs, local celebrities, Japanese tourists in high summer dressed in black taking pictures nonstop. Bondi is just Bondi.

*What influence do you think street fashion trends have on mainstream fashion in Australia?*
A huge influence. The kids are there waiting for the new trend; they are hungry for the new. Street fashion is a reference for absolutely every designer in the world - street is art, is real, it is our jungle.

Mainstream is good too; it means that the world is communicating and people are talking the same language. It's just the way one interprets the mainstream to oneself; we should all transform the mainstream with our own unique version.

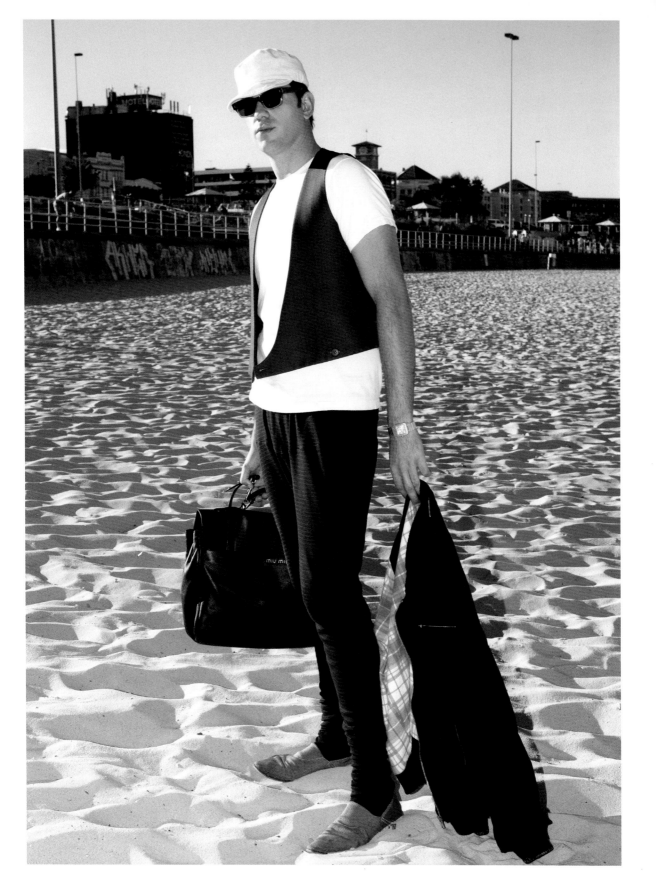

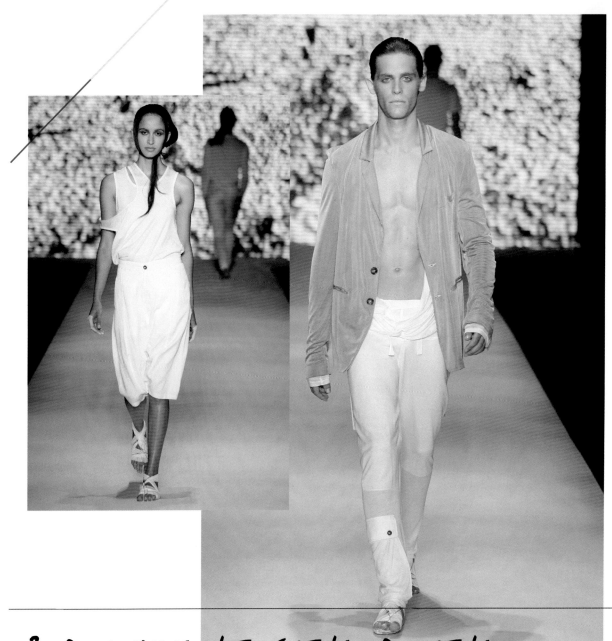

BONDI CAN HAVE A LOT OF STYLE AND NO STYLE IN THE SAME SQUARE METRE AND THAT'S OKAY!

*Describe your fashion label.*
To describe my own label is like a mother talking about her child. I can say that I try to keep it classic with an edge. I like to work with luxurious fabrics, which takes the label to a higher level. I can also say that I put my heart and soul into it and that I design clothes that I want to wear.

*Who or what are your influences?*
My background and family - I grew up in Brazil in a very aristocratic, colonial and traditional family but my parents were quite naughty - maybe they're still naughty! I experienced a lot in my own backyard. I understood very early how to keep an old-fashioned elegance while incorporating modernism and a sexy, slightly edgy quality to my style.

*To what do you attribute the massive success of local labels like Ksubi?*
I think Ksubi is brilliant; brilliant in the way they mix what I am talking about. Ksubi became a gang of good-looking people having fun. I respect that very much; it's not just street wear, it's generation wear; it's the music you listen to and the jeans you wear while doing it.

*Street fashion vs. high fashion seen on runways: which way do trends filter?*
Street fashion sells, therefore the catwalk follows the street and the street follows the catwalk. That's how the universe works or it should work. Sometimes I see things in Bondi that it could be in the middle of Paris and vice versa.

*The vintage clothing trend, ever-popular in Bondi: where's that at?*
I really love the vintage trend obsession.

We certainly should be recycling the world and that includes fashion. Who could imagine that you could look so hot in Bondi wearing your grandma's clothes that she wore in Bondi 40 years ago? See, as I say, things don't change, people don't change that much either - they just renovate themselves.

*What cultural or other factors do you believe are key influences in the style here?*
It is fascinating if you look at pictures of Bondi 50 years ago - you could see you they're hanging out at the beach having a good time. Today nothing's changed in that aspect -everybody is there to have a good time.

I love that no one can hide at the beach, it is bikini land - you run to the water half naked then when you're back you feel fresh, renewed and happy and that's the beach feel that Bondi carries on.

The style of Bondi is the freedom of being anonymous; you can take on a different character. The photos taken by Max Dupain (Australian photographer circa 1930s) explain a lot of what I'm talking about. Bondi can have a lot of style and no style in the same square metre and that's okay!

*What are your favourite things to do or see in Bondi?*
Well, that view, the water, the sand, the people and the cafés. I'm kind of unpredictable in summer, I like to go jogging in the soft sand and finish at the pool at Icebergs. In winter I like to sit at a café with a blanket around me having a hot chocolate and watching the surf.

I can shop in Bondi, well I can shop anywhere, but there is a furniture shop called The Market; it has amazing old and new furniture. I love to go there and spend a good hour. North Bondi Italian - yum - eggplant parmagiana, risotto balls, a good glass of pinot and again watching people, dogs and the time pass by.

Well, talking food, at the Earth Food organic store I love two things: when I'm in a healthy mood I have a natural berry protein shake; it is so good; but when I'm feeling a bit naughty I have two chocolate cookies that they home-bake every day at 4pm. The chocolate melts inside the cookie - it is the best cookie ever. I always go to my favourite masseur at Bondi Icebergs gym. I lay on that bed and I have the best massage listening to the waves crushing on the rocks - it's a great relaxing moment.

**BEN**

20

**PAINTER**

I'm wearing Lee jeans that I customised to look skinnier, a vintage vest and tee, Emerica shoes and a Tongan flax bag I got from Tonga.

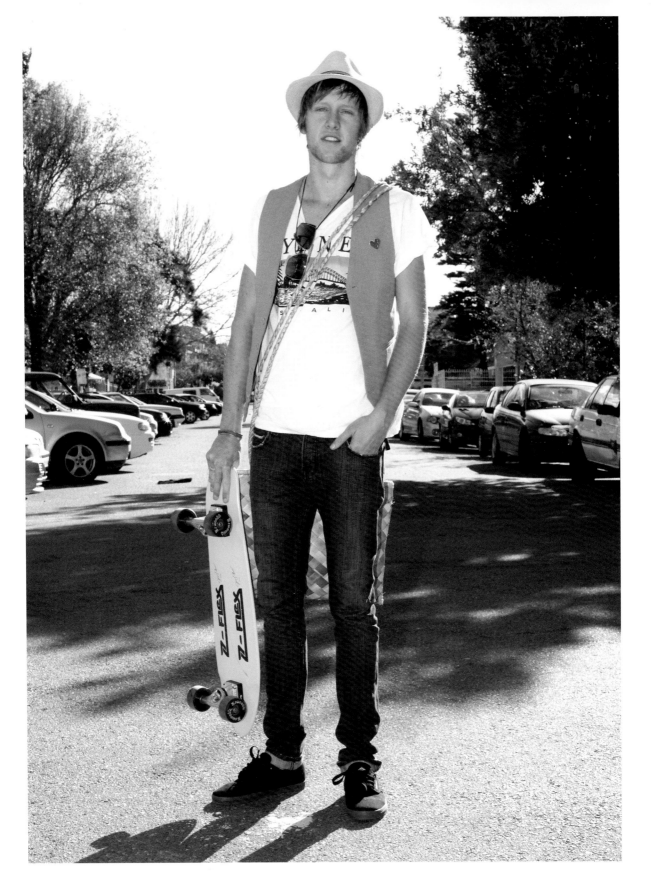

# ANNA

27

**WRITER / BUYER**

Crochet jacket from Puf 'n' Stuff, race car singlet from the Surry Hills markets, sunnies and jewellery from Harlequin Market and a Missoni bikini. I love Australian labels: MyPetsQuare, Ruby Smallbone, Chronicles of Never, Nathan Smith, Sam Elsom, Ellery, Camilla & Marc, Nicola Finetti and Fernando Frisoni.

*Bondi style is…* going out to dinner in the same clothes you woke up in.

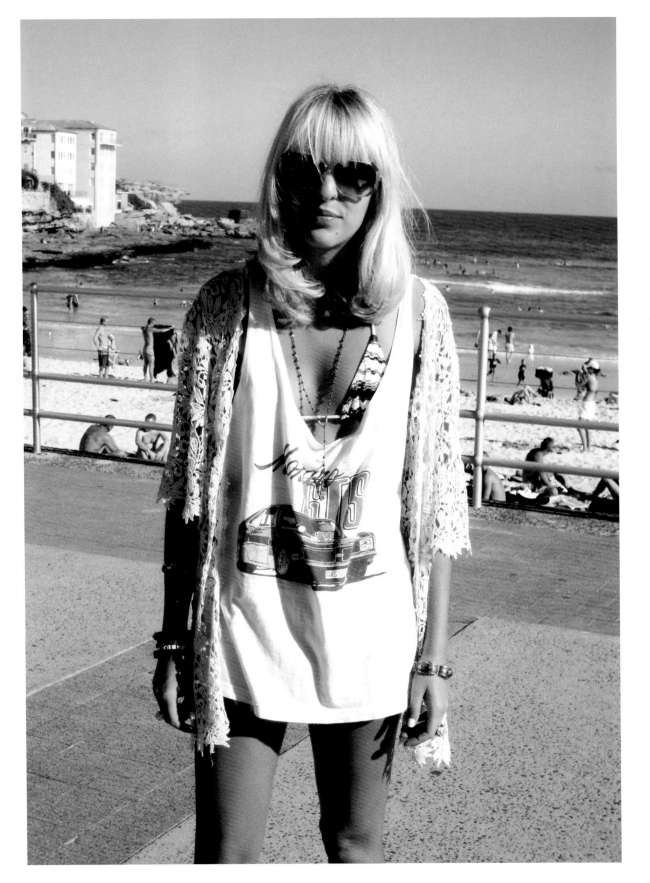

# BENNI

25

**SALES**

I'm wearing Lee cut off jeans, an Arthur Galan cotton flannel shirt and Bally loafers.

The beach defines Bondi's style and the diverse range of characters it attracts. This contributes to the range of fashion trends – some clean, some dirty.

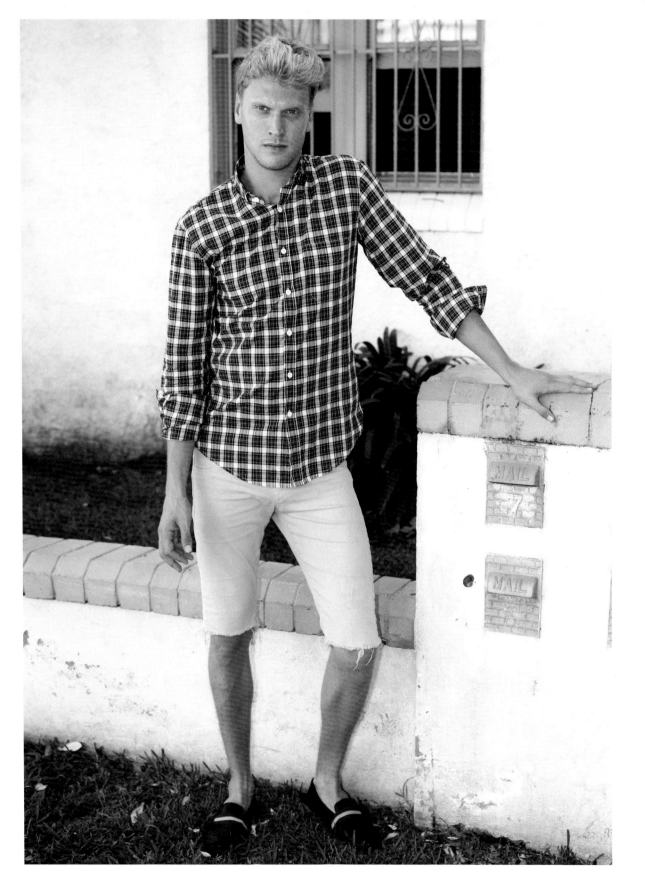

My STYLE MOTTO iS... LIVE FOR YOURSELF; LOVE WHAT

# DON'T

# BE AFR

LUCI TAFFS, DESIGNER

YOU WEAR

AID

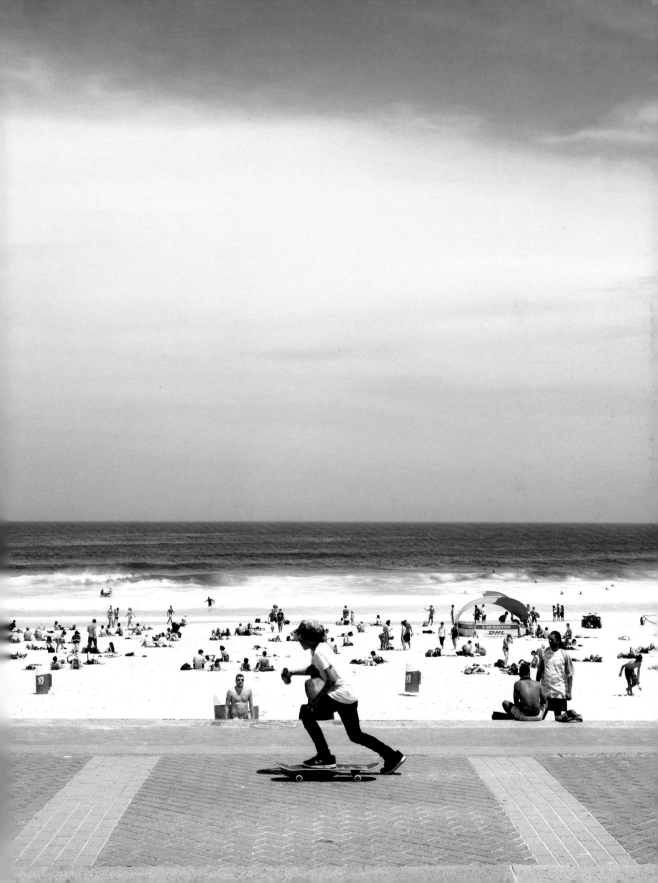

# CHRISTINE (APPLES)

28
**CREATIVE CONSULTANT,
TREND FORECASTER**

Vintage boots and shorts from Puf'n'Stuff; shirt from 'Chapel by the Sea' op shop.

*What are your top places to uncover upcoming trends?*
Top places I recommend would definitely be Puf'n'Stuff vintage clothing and Bondi Markets. I find they are very on to it when it comes to forecasting upcoming trends and I always feel inspired when I visit.

*Your predictions for the next big trends?*
I'm feeling a real oriental vibe again. Silky kimonos with accentuated fringing, Chinese style silk jackets too. I have always been a fan of wearing denim on denim i.e. denim shirt and shorts/jeans combo. It is such an effortless look that anyone can easily dress up or down. Finally I'm rockin' out my ankle cowboy boots again! Feeling very Western-inspired and I'm loving a satin Western shirt teamed with a suede mini A-line skirt look. Maybe a bit OTT but I love it!

*Do you think Bondi locals are trend focused?*
Bondi locals are trend-focused in the way that our community allows us to express how we feel when it comes to clothing and no one makes you feel out of place for it. Or so I think! Ha ha.

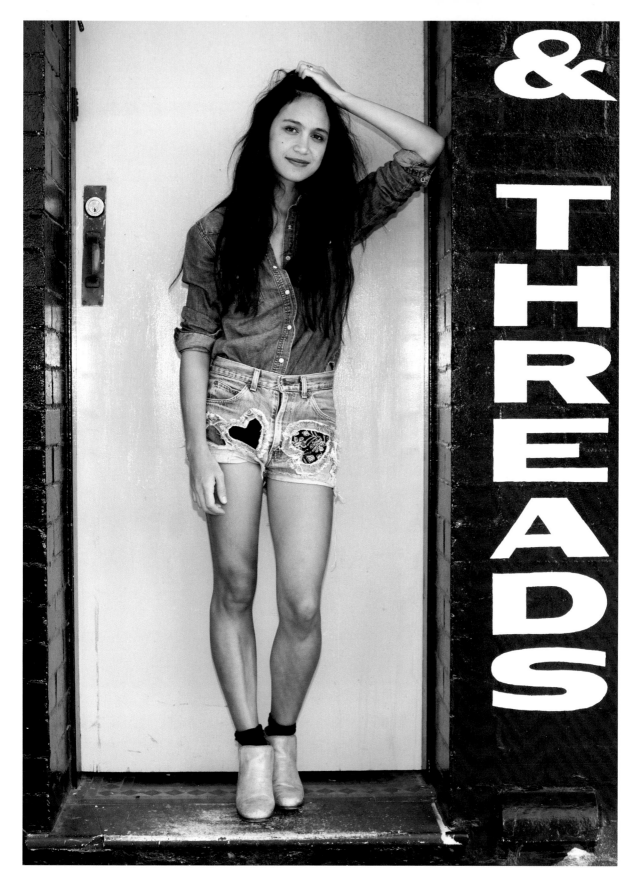

& THREADS

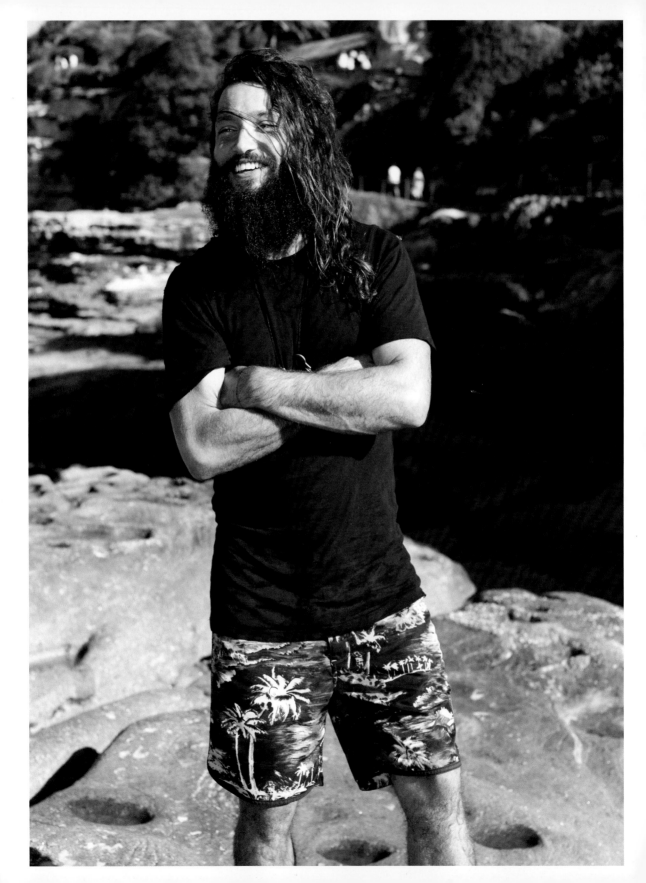

# DION ANTONY

INSTALLATION ARTIST

Deemed by his peers to personify Bondi, Dion Antony is an enigmatic, self-trained installation artist. His art has adorned myriad 'canvases' from Ksubi's Melbourne store to the set of the MTV Awards.

*You're more or less synonymous with Bondi…*
Yeah, if you Google my name there's an interview with Dan (Single, from Ksubi) where he's asked 'If Bondi were a person, who would it be?' – and he says me.

*How long have you lived here?*
I've been living here 12 years. It's still clean; it's creative. The collective of people where everyone's mates – you don't get that anywhere else I've found.

*Describe what you do for work.*
I build weird things for weird people (laughs). It can vary from building a house to art installations.

*How did you get started in this line of work? What's been your path?*
I was a chippy (carpenter) with no formal training and I got sick of being on building sites. It was a natural progression - I knew people in the creative industry; then people got me to build things for them.

*What materials do you work with?*
Usually timber; I source from a few places – I like going to Heritage Building Supplies, they have nice cedar. It's beautiful to work with – when you cut it you can smell it. It's pliable, light and it has a beautiful grain.

*What are your influences/sources of inspiration?*
I don't look at other art because everyone I know rips their ideas from somewhere. It's not a conscious decision; I've never thought about it. If I were in an office I'd probably look at art on the net and buy magazines and that would definitely influence me.

*What's the process?*
For example, I'm about to do an installation at the Darko shop for the Illionaire range. So, I'll look at the range, speak to the designer, then sit and think

about what would work well for the brand and their persona. It goes from there.

I just did a thing for Kirrily Johnston's studio; she wanted to tile the floor with black and white checks but the floor's really uneven and would've cost seven grand to fix, so I ended up painting the checkers on – it looks great. I also arranged her photos. Basically, I feed off the client and if they're not happy I start again.

*Where can people see your work?*
Ksubi's Melbourne store – I did the interior fit-out. I do a lot of installations so unfortunately most times the work gets torn down. I just built a seven metre snowman from garbage bags for a vodka company, which was on display in front lof Customs House at Circular Quay. We built a hamburger out of cars – that was for the High Street in Armidale (Melbourne) for an annual event called 'High Art'. All the stores do an art installation to attract people to the area. The hamburger was made from Mini Minors. It was supposed to be made from dildos but they were too expensive.

*Other notable or unusual projects?*
I built a 20 foot wide chair from pine, for a Harper's Bazaar shoot once; the model had to use a ladder. I built it in the street as I had nowhere else to build it. People didn't know what it was – I told them to go across the road so then they could realise what it was.

I also went gold prospecting in Western Australia for six months. I was on the way to a wedding and the driver we had had all these pictures of gold nuggets in the car. He showed me the pics of nuggets and I was pretty intrigued - I said next time you go I'm coming. I ended up going to the desert and made a jewellery range from the gold nuggets I found.

*Why do you think there's this creative community in Bondi?*
Anyone who's creative enough to make a living out of it is going to flock to a place where there are a lot of others like that. All thought and matter is energy so if you're on a certain level, you attract what you are – you're attracted to places with like-minded people, or you're like me, you've been here 12 years and you're stuck with it (laughs). It's so expensive here now.

*How's that (the expensiveness) going to affect it?*
Everyone's going to piss off. It happened to Venice beach, it happens everywhere,

wherever there's a community of like-minded artisans. They come into the area and they sit in these coffee shops because they have no money, reading books, coming up with ideas and all of a sudden every yuppie wants to hang out there.

*What else do you have in the pipeline?*
I'm about to open a restaurant in Bondi called 'The Old Man and the Sea' – I liked the title, it's a Hemingway book. It won't be my place, it'll be everyone's place; you know, if you want to come and put music on, you can. It's expensive produce but a cheap meal. It's what your mum used to make – bangers and mash, steak sandwiches, salt and pepper squid.

I'm going to build the shop for Illionaire and ACG and I'm going to do Nathan Smith's office. I'm also going to 'Burning Man' this year. It's a bunch of artists who lie in the desert near Death Valley, take a lot of drugs and build weird shit. It's the epicentre of installations these days. It's whatever you can imagine that you can trek into the desert, put together and leave without a trace.

BONDI IS A COLLECTIVE OF PEOPLE WHERE EVERYONE'S

MATES. YOU DON'T GET THAT ANYWHERE ELSE I'VE FOUND.

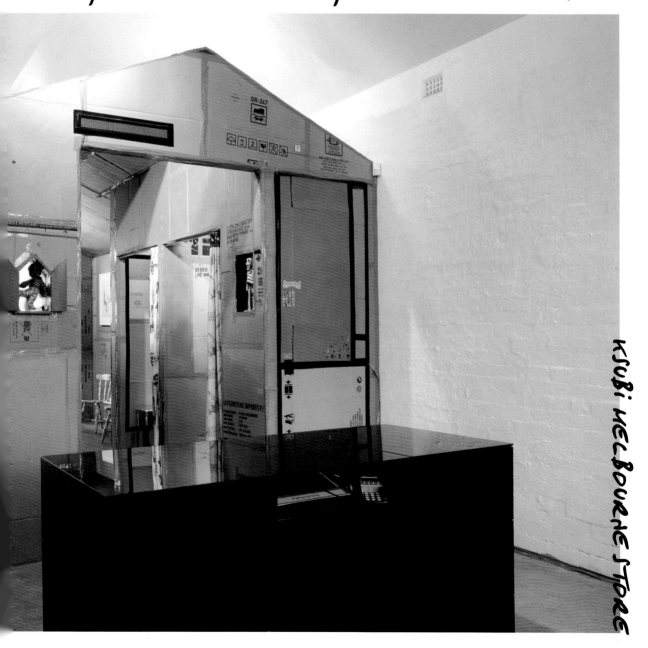

KSUBI MELBOURNE STORE

# MARINA

26
**STYLIST**

I'm wearing a Stolen Girlfriends Club singlet, vintage jacket and shorts and a Chanel scarf.

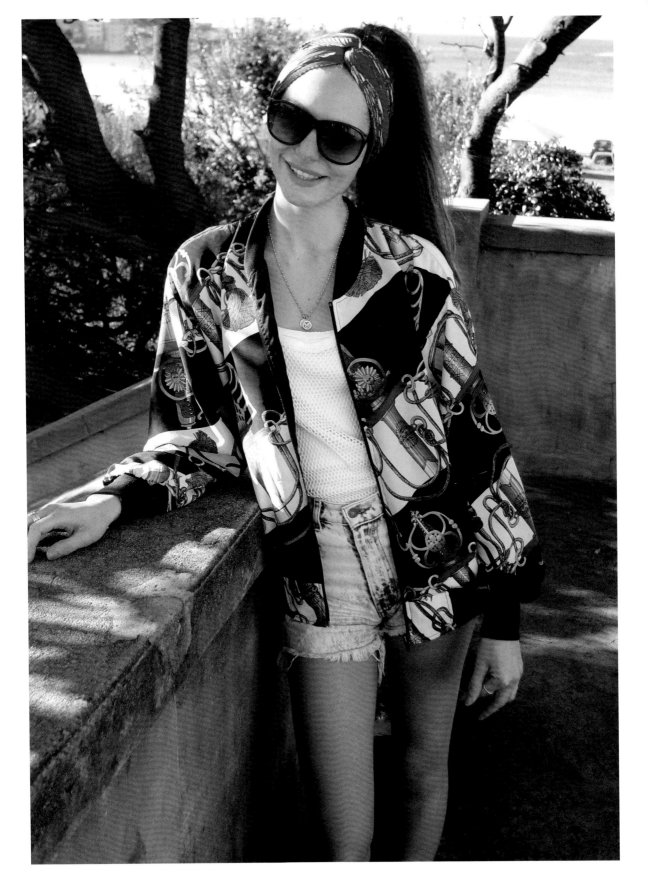

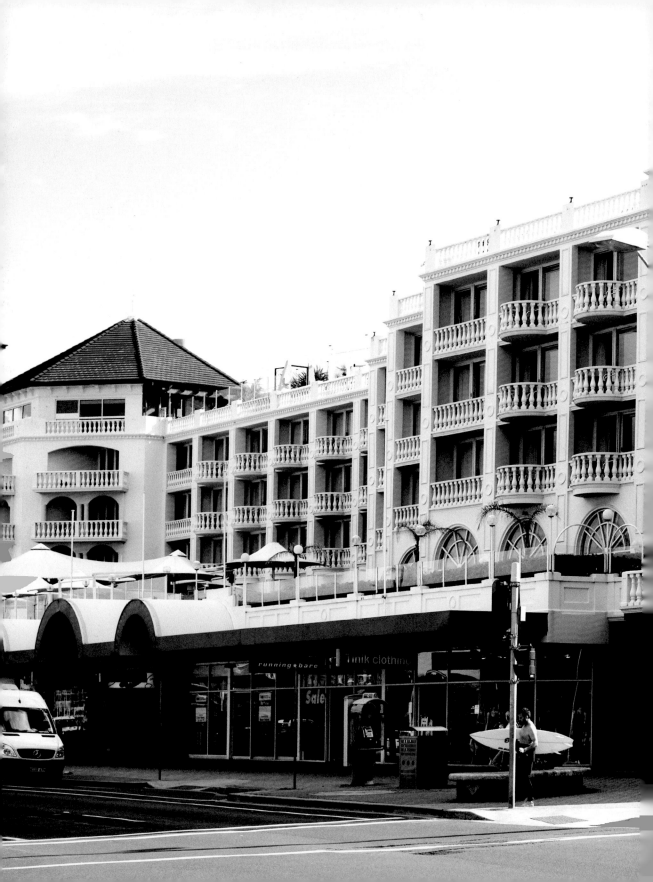

# LUCI

25
**DESIGNER,
LUCI IN THE SKY LABEL**

Vintage jacket from Hong Kong, vintage dress, Fendi necklace, Costume National boots and a Chloe bag.

My style motto is live for yourself; love what you wear. Don't be afraid.

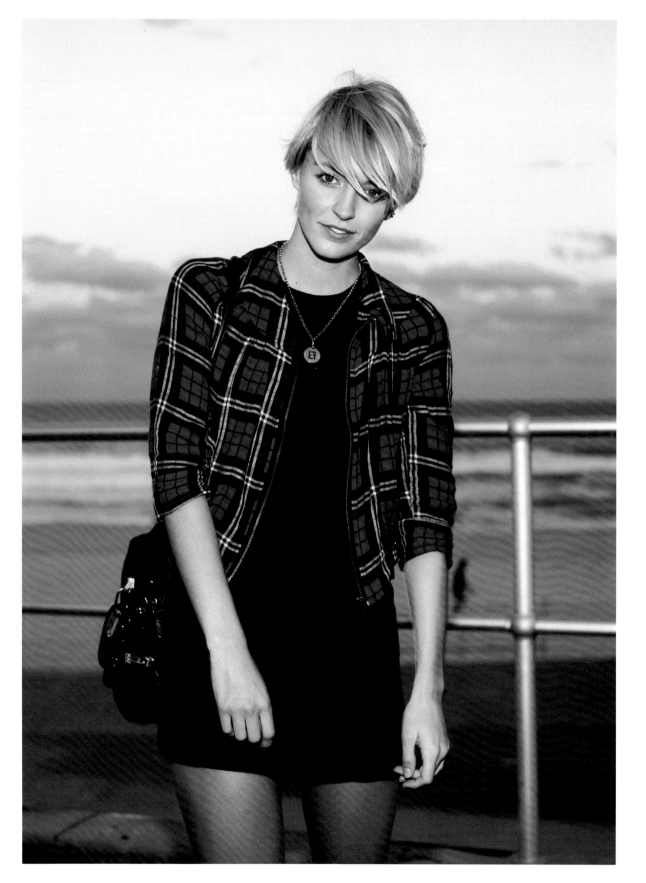

# ALINA

20

**MODEL**

I'm wearing an American Apparel sweater, Friedrich Gray dress, Nine West shoes, vintage Chanel bag and Ray Ban sunnies. Mum's a jeweller so she made most of these necklaces.

# GRAZ MULCAHY

## DESIGNER,
## GRAZ EYEWEAR

He started AM and Ksubi eyewear and
now has his own self-titled sunnies label,
Graz. With a true cult following, Graz
Mulcahy's sunglasses are in demand
worldwide. Graz also graces the decks
at many an A-List party.

*Why are sunnies so important in the
'Bondi wardrobe'?*
The sun is always shining in Bondi,
haven't you seen the brochure?

*What would be the most popular styles?*
The KMC for the men and the EDEN for
the ladies: two key styles of mine.

*Some people say you can tell a lot about
a person by the shoes they wear or the
bag they tote –what can you tell about
a person by the sunnies they wear?*
Well, many would argue in this day and
age sunglasses are far more form than
function. People pay more attention to
what they wear on their head than what
they wear on their feet (some obsessive
women aside). So in saying that,
sunglasses definitely say more. People
spend more time and effort on glasses,
not only because they are on your head
but because it's harder to find a good
pair that fits, that not everyone has and
that doesn't cost an arm and a leg.

*How did you get into eyewear design?
And your own line?*
I've been designing stuff for a while.
It just came as an idea. So many
sunglasses; not very many good ones.
It was a 'meant to be' thing I think.

*Tell me about your latest range.*
It was my first 100 percent solo project.

I have collaborated with many people in the past, whether they be partners, another brand, or consulting. This is my first thing without other heads involved in any part of it. It's been great; the luxury of doing what I want, how I want. The results showed that I operate the best this way.

*Do you feel your habitat influences your designs?*
Of course I soak in everything around me; that's what makes the landscape of my inspiration. I try to not make all of my influences and surrounds bias any particular geographical location or theme, but Bondi definitely has a lot to offer.

*Describe the design and product development process – how do you go from original idea to finished product? Where does your design inspiration come from?*
First an idea; then a sketch. From that sketch it then goes into the computer. I develop a shape and then apply the appropriate measurements. Because my frames are made by hand they have to be cut from a sheet. So I do a front, top and side view with the specifications and then prepare the data for the factory.

My inspiration comes from just about everything I do; everything is linked. How I feel, the work I do, the people who buy my designs – it's all in the same system.

*Where can we find your sunnies?*
You have to look, but they are not too hard to find. They are in 10 stores in the world. Also I have a group of people that get first dibs on my frames. They are shown and offered firstly to a global community of people who are friends or fans of my designs; they are then released to a small number of stores.

*Do you feel you compete with the major global brands?*
Yes and no. Yes because everyone has a choice and some of the global brands make great sunglasses and if no one bought mine then I wouldn't be able to do what I love.

No, because I do it because I love it, not to make millions, so I don't really care if they sell more than me, or have bigger posters.

*Would you like to expand your collection to other products in the future? If so, what?*
Most definitely, I've always had my eye on luggage, perhaps some shoes and definitely some domestic household items – light covers, cups, etcetera.

*And if you weren't designing eyewear, you would be…?*
Dead.

*Like a few other designers, you also DJ: what kind of music do you play/are you into?*
Everything. The last five songs I just played were Miles Davis, Faith No More, Larry Levan, Daft Punk and Wu Tang Clan.

*What do you like most about living in Bondi?*
It's pretty carefree. There are some great cities and places in the world, but I've realised nothing compares to the Bondi area. It's pretty hassle free except the parking rangers. Trying to ruin people's little lives.

*What do you think it will be like in 10-15 years' time?*
That's up to the council I guess. If I was a betting man I'd say that it'll either be like the Gold Coast (Queensland) or maybe the world is going to end before then anyways…

GRAZ EYEWEAR

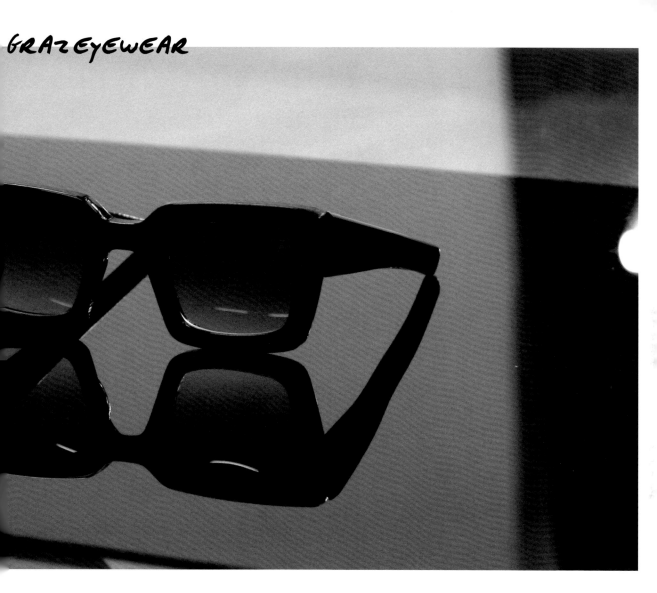

THE sun is always shining in Bondi,

HAVEN'T you SEEN THE BROCHURE?

# CARL

33

## DJ / MUSIC PRODUCER

Vintage Harley Davidson tee, Ksubi jeans, vintage Christian Dior sunnies, a vintage belt from Puf 'n' Stuff, Matt Weston necklace, Versani bracelets and an American Indian ring from a store in Bondi Junction.

I came to Sydney on tour where I met my now wife. For me personally at that time, New York was in decline and Sydney was coming up. That's now turning around for me so I'll be heading to spend quite a bit of time in New York again soon.

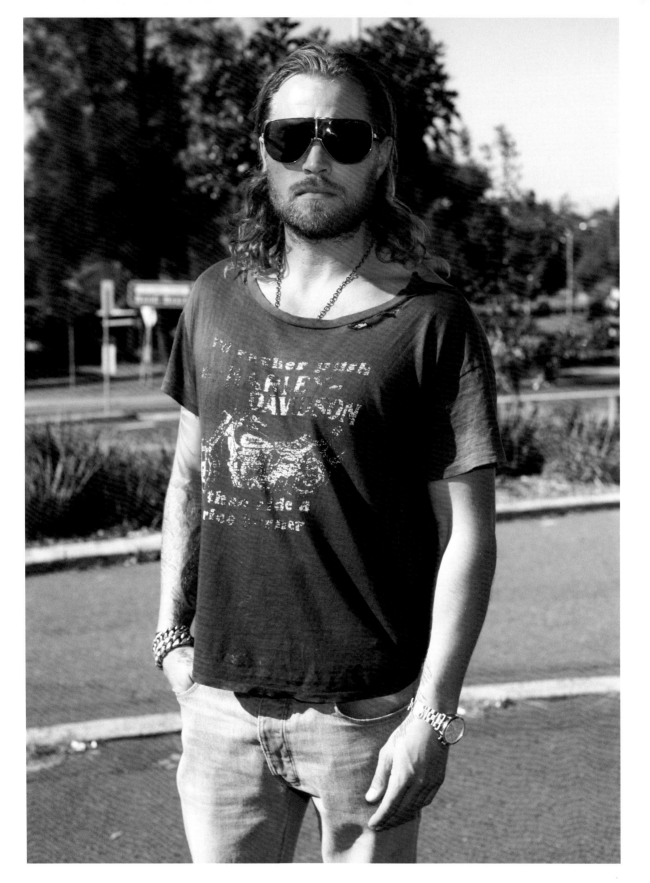

**ALEX**
26
**DRUMMER**

I'm wearing a Stubbies tee, Paige jeans, Graz sunnies and Fantasy boots from London. My friend makes them – pretty outrageous for down here at the beach – you should see my boots collection!

I've just been in LA – I am a session drummer. I've been playing with Nine Inch nails, Kelis, Phoenix and Robbie Williams. Australia's flavour has really penetrated Hollywood –Aussie labels are doing really well there and there are lots of Australians in LA.

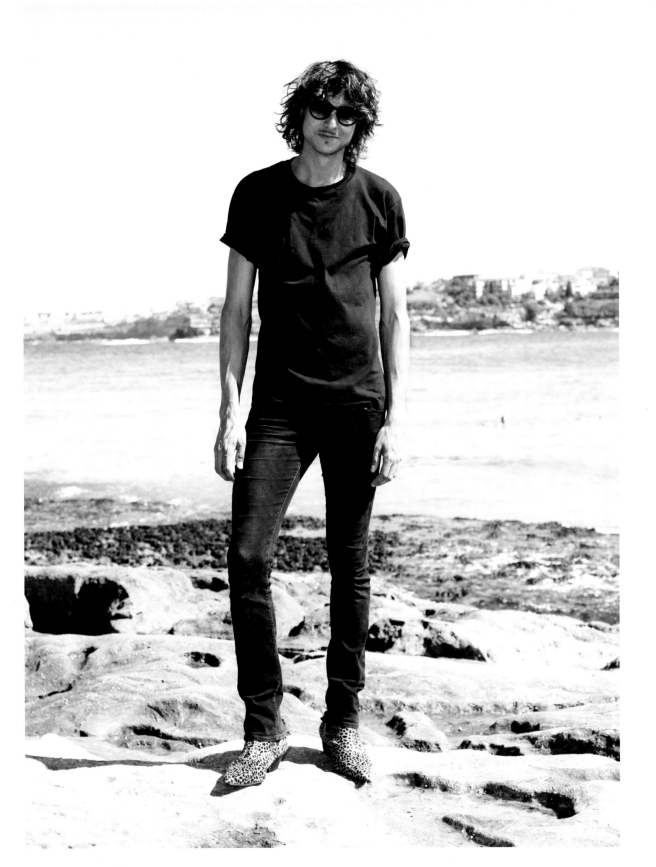

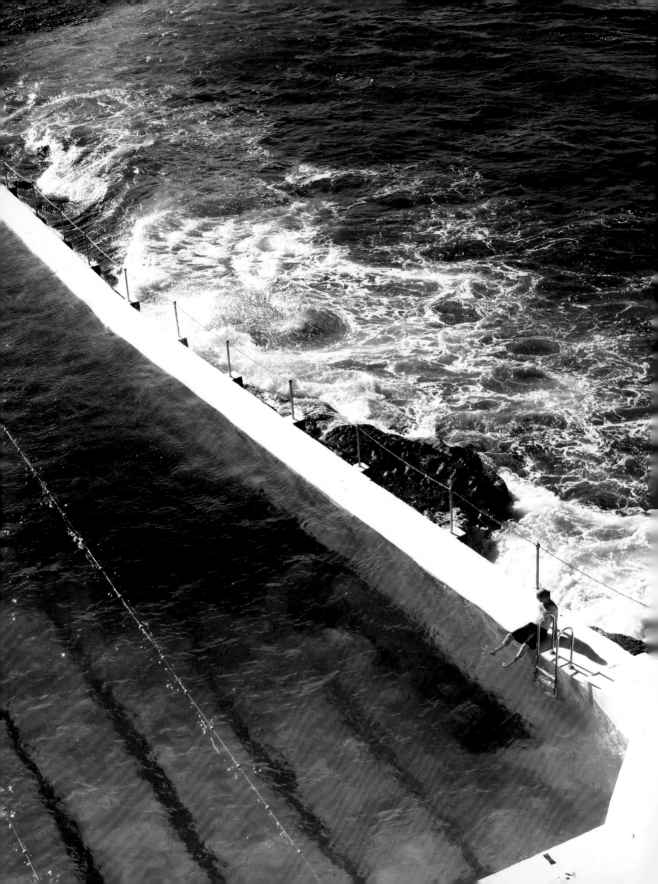

iT'S A GOOD BEACH FOR A BEGINNER.

...iT'S GOOD FOR ANYONE. THE MORE, THE BETTER.

SAM MCINTOSH, STAB MAGAZINE

# ANGUS MCDONALD & DAIMON DOWNEY

## SNEAKY SOUND SYSTEM

Sneaky Sound System is the quintessential Bondi music group, having had their humble beginnings locally and maintaining a strong following there. Sneaky is a four-member electro/house/funk group whose founding members Daimon Downey and Angus McDonald live in Bondi Beach when they're not on tour.

*The debut album by this internationally renowned group went twice platinum, for which they received two ARIA awards and two AIRs. Their current album debuted at number one on the ARIA charts.*

*How long have you lived in Bondi?*
AM: On and off for about six years, although it feels like about 10 because I always seem to be in Bondi.

DD: I have been a permanent resident for about five years but have coming here on a weekend market and beach ritual for years and years.

*What is a typical working day for you?*
AM: There is no such thing. When we were making our first record I would spend up to 18 hours a day recording, tweaking and experimenting in the studio and at the same time Daimon and I were running our record label, so I was really, really busy. These days a normal day might include writing new songs, some recording, print interviews, radio and TV interviews, meetings, meetings, meetings, photo shoots, designing artwork, preparing for shows, filming videos, doing shows, travelling (lots of that), hanging out with my son and blah, blah, blah! I'm all over the shop.

DD: Either on the phone or on the computer; most often both at once. Our studio is also the office for Sneaky Sound System and Whack Records so there's always something on. It's all very convenient though, as we all live literally a block from each other and a block from the studio. So as you can imagine, getting out of Bondi can prove very difficult unless we have a gig.

*How do you feel being based in Bondi influences what you do?*
AM: If anything it makes our life easier, because we all live so close. I don't think it necessarily influences the music, more so our state of mind.

DD: I don't think it influences our music as such because music influences come from all directions. As a work environment I think it keeps us all quite chilled - we try to avoid the city at all costs (that's not to say I don't love you Sydney!).

*Do you think there's a particular sound that's emerged in the Bondi scene, and do you think it's present in your music?*
AM: If anything it's a real melting pot of different styles, although it could be said that people in Bondi like their music 'up' – but I think that is Australia in general.

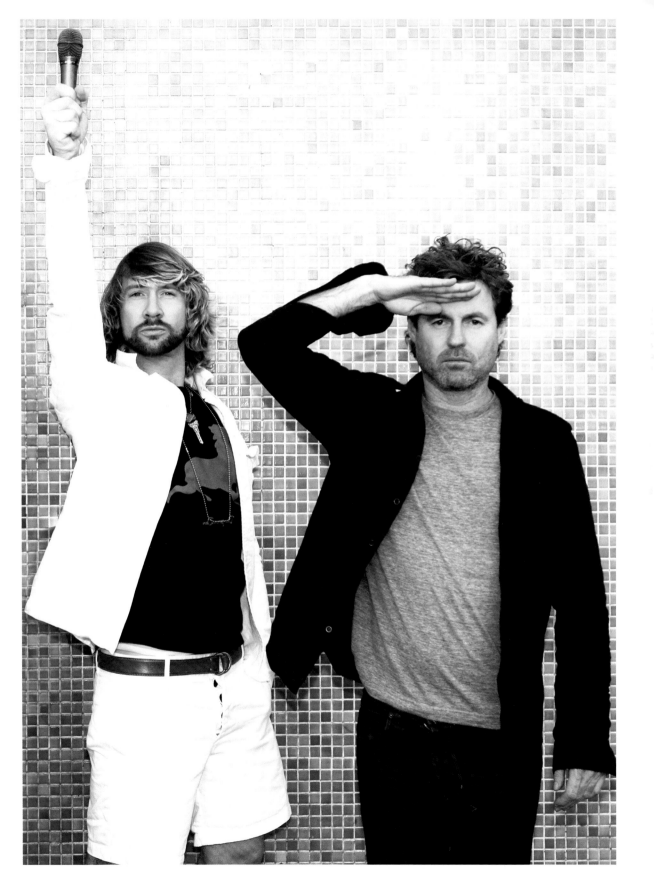

Our music is very 'up' so I guess that common thread exists.

DD: I do think Bondi has produced a sound that goes down the relaxed summer vibe side of things. That usually is along the reggae, funk, soul tip. A hippy, carefree attitude is actually represented in bands from Bondi. I don't think we typify a Bondi band, but our attitude shows what a Bondi person likes. A good time, around great things!

*Did you find you had a strong following in Bondi in your early days as a group?*
AM: Definitely in the early days, although once we moved our club nights and parties out of Bondi, it wasn't easy to move Bondi people out of Bondi – now that is a mission.

DD: When we first started Sneaky Sound System in its former life eight years ago, one of the early venues we played at was The Point of View on Campbell Parade. It was the size of six matchboxes but we still would cram over 100 people in there (licensed for 30) every Sunday. The footpath would be buzzing and somehow we got away with it. Locals only! It seemed that was the only gig the Bondi crew would go to. As I said it's pretty hard getting out of Bondi unless you have to.

*How developed is the local music scene?*
AM: There has been a quiet revolution brewing in the Australian music scene for the past few years and in the next year or so I think it is really going to come to a head. There are so many new producers and bands that are doing well here and around the world. We recently returned from a month in Europe and there is a huge buzz on Australian music right now, so exciting times are afoot. At least half a dozen are based here in Bondi.

DD: Bondi does have a few live venues, which is more than I can say for other parts of the city, but I think a lot more can be done in the way of outdoor live music whether it be world, rock, dance, whatever. We have beautiful spaces - let's use them!

*The nightlife scene?*
AM: If you're looking for nightlife get out of Bondi...pronto! Elsewhere, if you're

young and ready to rumble, chances are you'll have a whale of a time.

*What are your favourite places locally: To eat?*
AM: Breakfast at Jed's or Aqua Bar; lunch at Earth Food Organics. Most nights of the week we have dinner at North Bondi Italian Food or Icebergs with our good friend Maurice Terzini, and nothing beats a long weekend lunch at Sean's Panaroma. Bon Appetit.

DD: Jed's for breakfast, The Earth Food Store for lunch, Icebergs Dining Room & Bar for something fancy and North Bondi Italian Food all the time, any time.

*To shop?*
AM: Straight down Gould Street to Ksubi for some black jeans and a T, then to General Pants for a pair of crisp white Converses.

DD: Getting lucky at the Sunday markets is always a bonus.

*To go out?*
AM: Save it all up for New Year's Day when Sneaky Sound System and Icebergs clear out the furniture and have the mother of all parties.

DD: Getting carried away at The Beach Road or staying out for dinner for as long as possible is about it for me and Bondi - unless someone volunteers their house.

*What are you listening to at the moment?*
AM: I'm buying lots of records at the moment - getting ready for the summer party season - so far it's mainly deep and dirty minimal electro.

DD: Donnie Sloan, Bloc Party, Pacific, Former Child Star, Kings of Leon and Phoenix.

*What are your main musical influences/ inspiration?*
AM: They are everywhere. Some of the bands/acts that have made a lasting impact on me are: Bloc Party, Daft Punk, Hot Chip, Whitest Boy Alive, Kings of Leon, Les Rythmes Digitales, The Jam, The Smiths, Prince, The Cure, New Order, Blondie, Human League, Fleetwood Mac, Depeche Mode, The Cars, Duran Duran, Talking Heads, Devo, Eurythmics, Grace Jones, Kate Bush, Robert Palmer, Pink Floyd, David Bowie, Howard Jones, Prelude Records '80-'82, John Lennon, Quincy Jones, Chaka Khan, Michael Jackson, The Beatles...the list is ridiculously long, but you get the idea.

I DO THINK

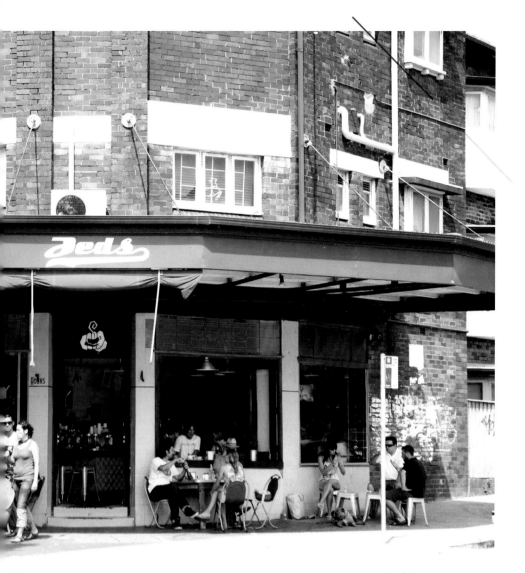

BONDI HAS PRODUCED A SOUND THAT GOES DOWN THE

RELAXED SUMMER VIBE SIDE OF THINGS.

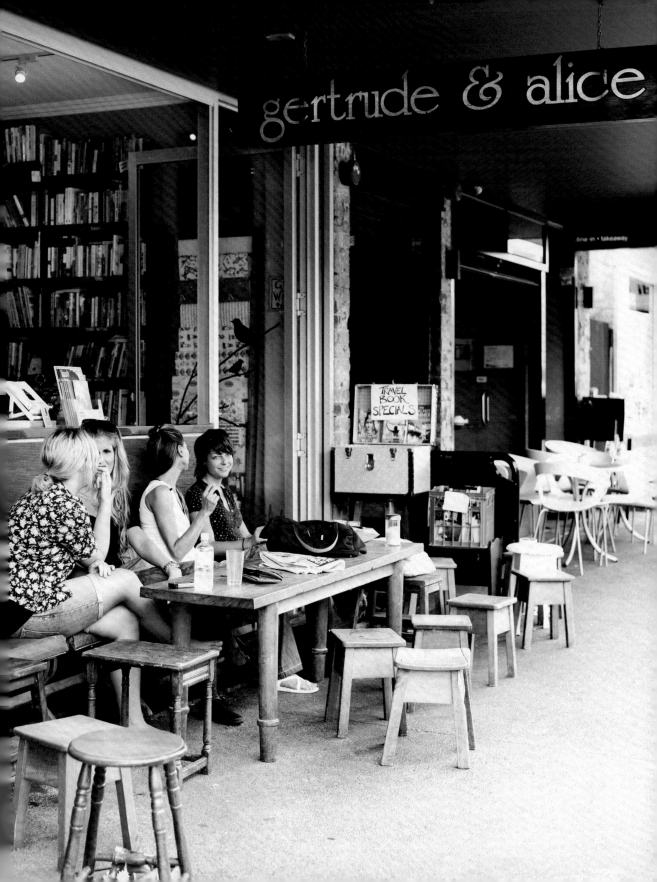

# DAMION FULLER
# & FERN LEVACK

### DESIGNERS,
### HOTEL BONDI SWIM

This husband and wife duo, formerly
of surf brand Kitten, has made
swimsuits their new artist's canvas,
imbuing them with locally referenced
motifs. Ironically named Hotel Bondi,
the label is homage to their home
of 18 years.

THE TYPICAL BONDI GIRL. SHE IS JAPANESE, BRAZILIAN,

ENGLISH, ITALIAN OR AUSTRALIAN AND WOULDN'T WANT TO

BE ANYWHERE ELSE THAN SWIMMING AT BONDI.

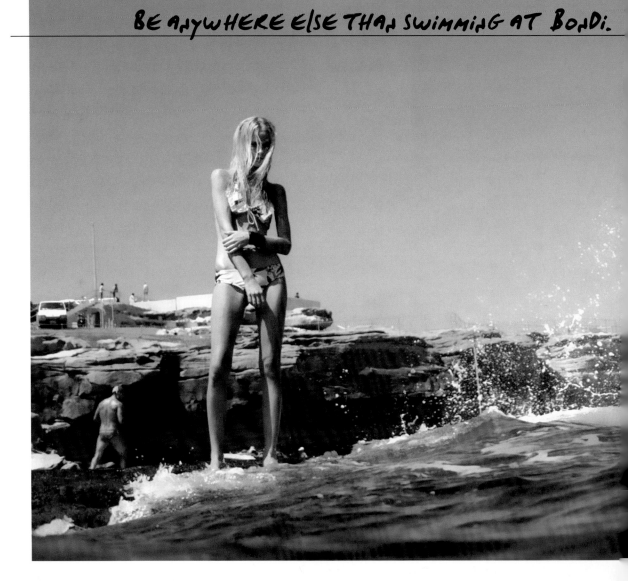

Hotel Bondi Swim

*Why did you call your label Hotel Bondi? What is people's reaction to the name?*
FL: We were attracted to the straightforward unpretentiousness of the words. Hotel and Bondi. Separately the word 'hotel' signifies relaxation, luxury, grandeur, magnificence and splendour and 'Bondi' means Bondi. Then of course is the irony and humour in the name that would be apparent to anyone who's been inside the actual Hotel Bondi, which is not very glamorous. Yet at the same time its pretty arches, lacework architecture and pastel ice-cream coloured paint work are also very sweet and unique.

*Describe the essence of the brand; its target customers etc.*
DF: We are interested in what's defined as 'the new luxury'. Bespoke touches; originality; hand-drawn art work and beautiful fabrics and fits. Our target customer is the typical Bondi girl. She is Japanese, Brazilian, English, Italian or Australian and wouldn't want to be anywhere else than swimming at Bondi.

*How long have you lived in the area? What drew you to it, and what keeps you here?*
FL: We have lived in the area since 1989 and Damion still yearns for the return of Bates' milk bar on the corner of Hall St. Bondi is like no other beach suburb in the world. It's a wonderful, eclectic mix of age groups, cultures and socio-economic groups. But the thing that unites everyone who comes to Bondi -visitors and locals - is that they have come to have a good time, to relax and enjoy that all-pervasive atmosphere that can be felt at any time of the day, all over the area.

*What was your fashion/design background prior to starting Hotel Bondi Swim?*
FL: We both studied at UTS Sydney and have degrees in Industrial Design and Textile Design. Damion was Senior Designer at Mambo for eight years and I worked with Collette Dinnigan for three years. Together we began Kitten, a boutique surf brand with stores in Bondi and Paddington. Kitten was sold internationally to stores such as Harvey Nichols and Selfridges in London, Patricia Field in New York and Fred Segal in LA. We sold the brand in 2005 when we realised we wanted to focus on the textile design side of the business.

*What made you decide to go into swimwear?*
DF: We have always lived by the ocean, like most Australians, and swimwear is second nature to us. Fern's final collection at university was a swim range and since then we have discovered that bikinis make the best canvases for the sort of art we like to create. People really do appreciate the laid-back luxury in each piece. Of course it means spending a lot of time at the beach 'researching.'

*Do you have any 'signature' prints or styles? What do you do best?*
FL: Our specialty is our hand-painted and drawn prints, all based around Bondi themes. Our favourite from last season was a patchwork of watercolour squares in varying green hues – inspired by Bondi's tiny neglected front yards.

*Who are your major stockists?*
DF: David Jones nationally and Bikini Island in Bondi.

*To what do you attribute the huge success of Aussie swimwear on an international level?*
DF: The unquestionable authenticity of the designers who obviously know what they are doing. It's one of those cases where we really live and breathe the product.

*Are there particular styles that Australian swimwear is associated with?*
FL: I guess it's well known for having athletic fits to suit our lifestyle and less of the resort feels of Europe or America. More recently Australian swimwear is seen as a leader with its fearless approach to having fun with modern and retro styling -basically we aren't afraid to try anything or wear anything when it comes to swimwear!

*Do you find that people overseas have heard of Bondi? If so, what's their perception?*
DF: The Hotel Bondi Swim project began with a story told to us by a close friend who had just returned from Moscow. He had gotten into a taxi and the driver asked him where he was from. Our friend replied Australia and the driver turned in his seat and cried "BONDI BEACH!" giving the double thumbs up.

We realised all we had to do was be honest and true to where we are from and people would respond. All around the world Bondi is a place that brings a smile to people's faces – they think of colour, sunlight and a lifestyle most only dream of.

# MATTY

24

**STILL WORKING ON IT**

I'm wearing a vintage shirt and Stüssy shorts. My favourite labels are RVCA, Insight and Cheap Monday.

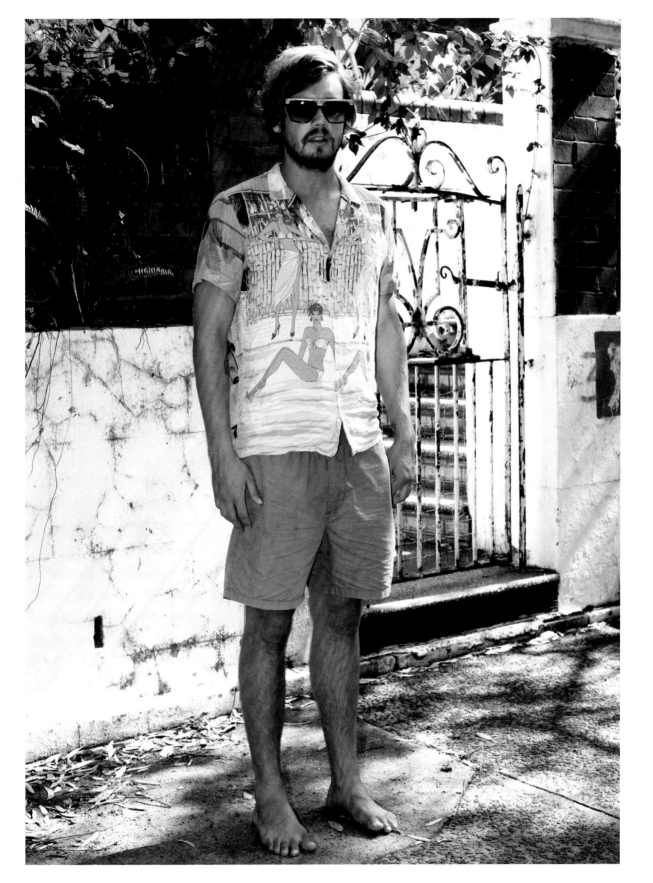

# KAT

22

**FREELANCE JOURNALIST**

I'm wearing a Deborah Sweeney dress from Tuchuzy and vintage boots.

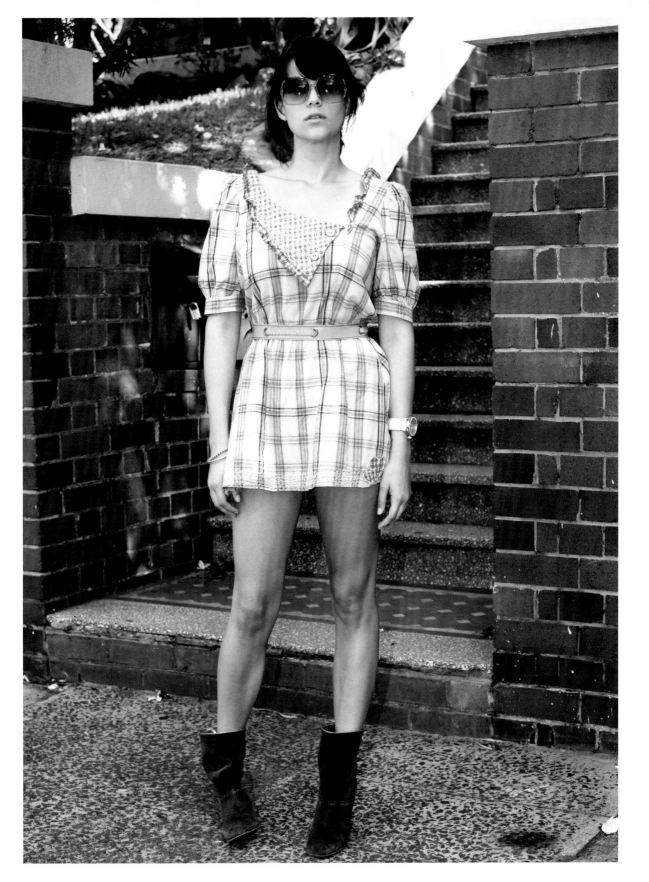

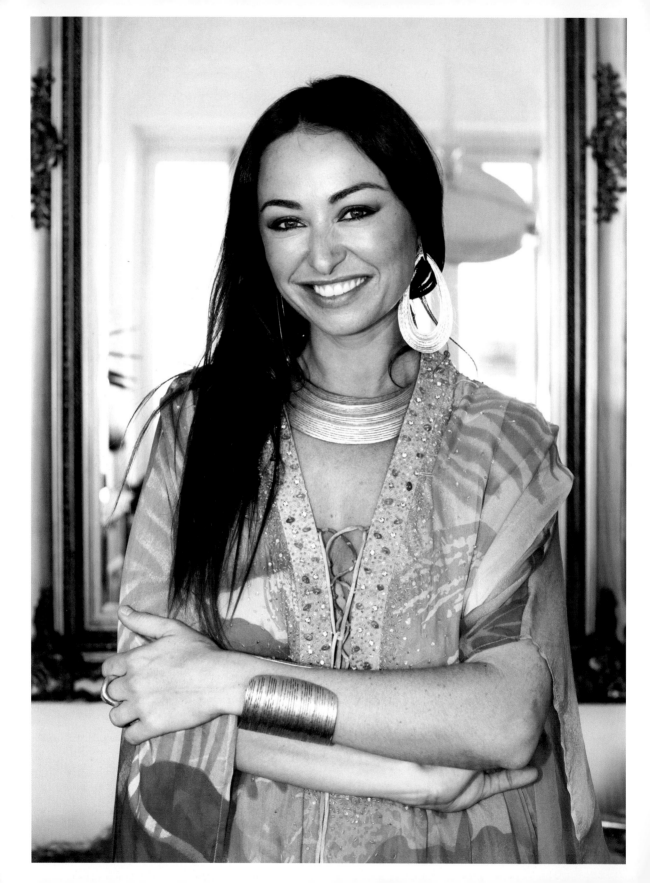

# CAMILLA FRANKS

## DESIGNER, CAMILLA

The Bondi flagship store of Australia's glamorous 'Kaftan Queen' Camilla Franks, is a beachside retreat in its own right, swathed in the floaty fabrics that fashion her garments. An international success, Camilla's creations have been worn by celebrities from Beyoncé to the Pussycat Dolls.

*Where did you grow up?*
I grew up in Watson's Bay (neighbouring suburb) surrounded by beauty and nature. It was a children's wonderland!

*How long have you lived in Bondi?*
I've lived in Bondi for four years.

*What brought you here?*
A love of the beach brought me here and also my flatmates of the time, my close friends Phil Caewood and David Lynch – being both keen surfers, they had to be close to the best waves in the East!

*Tell me about your background career-wise, and how you came to start your eponymous label?*
I come from a background in the theatre as an actress. I have no formal training whatsoever. I am definitely not the best on the sewing machine. My training has come from backstage in the theatre, sewing up the last hem of my flamenco dress for Isla or adding the last few stitches into a headscarf for Tatiana, Queen of the Fairies in A Midsummer Night's Dream.

*Why kaftans?*
My beautiful Mum is the original 'Kaftan Queen'. From as early as I can remember she was floating around in these unique designs that she collected during her travels and worldly adventures. This colourful influence made its way into my acting world, where I'd design flamboyant costumes for my fabulous characters.

*What was your first big break?*
My first big break was the launch of my label six years ago - how times flies! My first collection was showcased to David Jones department store during Australian Fashion Week. I remember I was staying at the Intercontinental in the Australia Suite pacing back and forth. I was so nervous, expecting no response really, so I was completely over the moon when David Jones bought my collection.

*Who are your fashion icons?*
Firstly, my mother is my main influence. Always has been. Maggie Tabberer is also a woman who epitomises unique elegance and style. I am a huge fan of the turban and her relaxed sense of elegance. Verushka's lifestyle is an image my label portrays in the here and now. The bohemian lifestyle combined with Sydney glamour is a perfect match. Talitha Ghetty is the original and most wonderful bohemian princess who lived and breathed freedom of expression through fashion.

*Who is the Camilla wearer?*
I have always had an 'all welcoming' approach to my clientele. My designs are timeless and size-less. The Camilla woman is free-spirited, confident, and celebrates a vibrant sense of joie de vivre. And most importantly, she is proud to be a woman.

*Who are some of the celebrities who've worn Camilla?*
Celebrities ranging from Beyoncé to Sharon Stone to Bette Midler are loyal clients. I have had the opportunity to meet incredible people in the music industry, like Paula Abdul, Fergie, Grace Jones, The Pussycat Dolls and Prince, who have all since become some of my favourite clients.

*What are your favourite labels?*
I admire Sass & Bide for building an empire; Willow for her creative and unique designs and Leona Edmiston for lasting the test of time.

*Why did you choose Bondi as the location for your first, and flagship, store?*
I think Bondi truly reflects my lifestyle from day to day and the laid-back feel to my designs. Jackie's, now 'Camilla's Beach House', used to be an iconic restaurant and bar. You walk into the space and immediately you feel like you are on holiday. The energy and atmosphere are a truly unique combination for anyone who steps through the door. Definitely a unique shopping experience.

*What does your usual weekend day involve?*
My daily ritual starts from 6am; I grab the love of my life Gypsy (half sharpie/ malamute) and dive into Mackenzie's rockpools, Tamarama, for a fresh morning swim. Brainstorming to do lists for the year by the time morning finishes becomes epic, like a War and Peace novel.
Bondi to Bronte walk with best friend Annalise. Then visit my 'Kaftan Queens' at the 'Beach House' where we spend the days trying to conquer the world of fashion. It's an amazing space to get the business brain working.

On a good day I usually finish in the office around 8pm and then I love to cook. I find it hard to cook for one, so it's usually a feast for whoever pops in.

*If you were to advise a tourist of the perfect way to spend a day in Bondi, what would you recommend?*
I would start the day off with the Bondi to Bronte walk; after this trek you're ready for breakfast at Earth Foods ... organic eggs, fresh juices. Once breakfast is finished I would potter around Gould Street through the shops then a few hours on the beach for some sun and surf.
Lunch would definitely be at Icebergs, starting off with a cocktail followed by enjoying Australia's freshly shucked oysters and our local whole fish. I wish I were there right now. Bondi lunches usually turn into dinners watching the sunset over Bondi Beach.

At the end of the day I love a walk along the promenade, especially when it's that really hot summer's night.

*What are your future plans for the label?*
Expanding further into the international market is definitely my goal. We are taking on more projects every day, from the launch of my leather bags collection to further partnerships within the tourism industry. We are currently collaborating with five star hotels, resorts, cruise liners and day spas around the world. Our aim is to share the essence of Bondi around the world!

OUR AIM IS TO SHARE THE ESSENCE OF

BONDI AROUND THE WORLD!

I love the fact that every day it gets  a natural
STEVEN PAVLOVIC, MODULAR RECORDS

facelift and that no two days look the same.

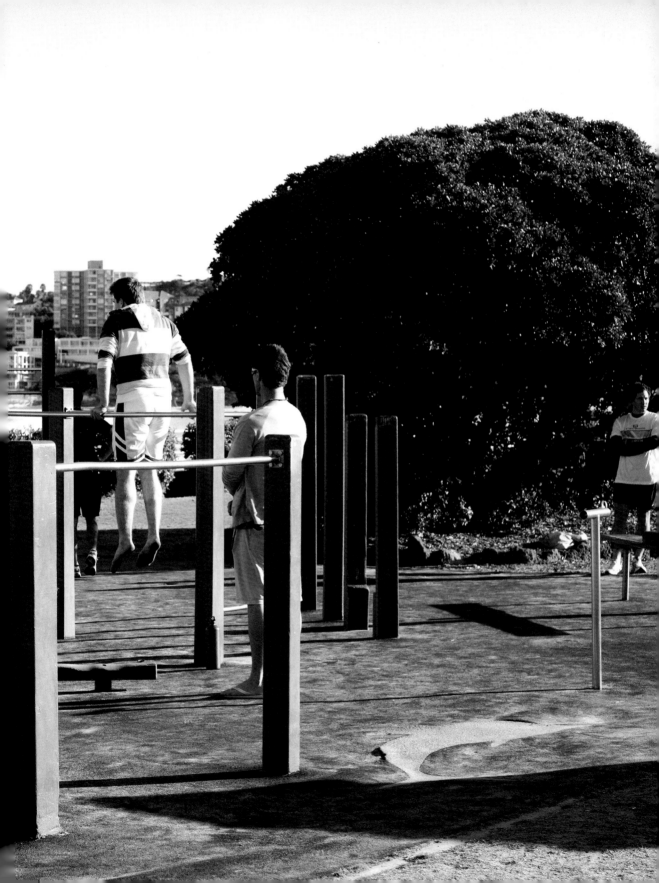

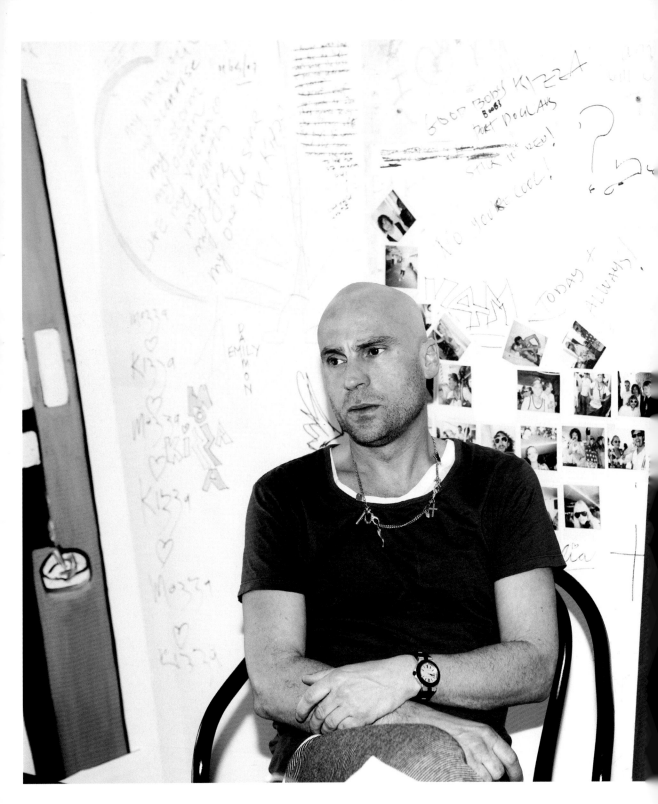

## MAURICE TERZINI
### RESTAURATEUR

Restaurateur Maurice Terzini nails
the drinking and dining Zeitgeist with
every one of his hospitality ventures.
He co-owns and runs two of the most
famed restaurants in Bondi Beach, if not
Australia. Icebergs Dining Room and Bar
is located on the water's edge of South
Bondi Beach while North Bondi Italian
Food, Icebergs' more casual cousin, is on
the opposite end of the beach strip.

*You're originally from Melbourne; what made you move to Sydney?*
Personal reasons and a very good commercial deal. I also looked at the Sydney market and felt no one was offering good bistro Italian food; it was crap or really expensive and good; nothing in between…that was the idea behind Otto Ristorante Italiano at the Woolloomooloo wharf.

*Do you consider it home now?*
I really don't consider Sydney home but rather Bondi. I try not to venture out too far. I have been across the bridge three times in almost nine years. Last year I changed my electoral enrollment to Waverley, however I still have a passion for St Kilda and Melbourne. My dream is to live the beach at Bondi and the city in Melbourne; perhaps six months in each city.

*How do you find both living and working in Bondi?*
Excellent; I stick to myself and have never had an issue with spending so much time in Bondi.

*How do you think your outlook is affected by living in the area?*
Well my lifestyle has changed, I still like a late night drink but I have been exposed to the beautifully daytime environment of the beach… it has given me a good balance in life.

*Why did you choose Bondi as a location for two of your restaurants?*
I wanted to own a restaurant that the world could look at. The brief to our architects was that we wanted people to know exactly where they were once they walked into the Icebergs. The Icebergs is truly a magnificent site and that's also why I chose it, although many people said we would not fill it.

North Bondi Italian on the other hand was such a wasted space and we believed that it was not catering to any of the local community. If we hadn't taken that space someone else would have; it was too good to give up.

*Who are your customers?*
Everyone: rich, poor, creative, actors, directors, musicians, businesspeople, mothers, children, surfers… This is the great skill that we have, allowing people from all walks of life to enjoy the same space. It is what gives a restaurant its energy and longevity.

*Do you think the restaurants are reflective of the local scene?*
Yes it has taken us some time to prove it, but I think North Bondi Italian showed the community that we understand Bondi and do care.

*Do you have any other projects planned for Bondi?*
A great bar; to challenge the local pubs. Good drinks, good ice, good glassware and in particular good product.

*Bondi has a real mix of dining/ cuisine styles – both high and low..*
I hope it never changes, whatever market you are in as long as you provide quality I think it is good for the area. The poor quality takeaways - get rid of them.

*To what do you attribute your businesses' success?*
Dedication, great partners (now) and a will to learn every day.

*How would you describe Bondi's style?*
Crazy, whatever, whenever.

*Do you think your look is typically 'Bondi'?*
No and yes, depending on the day.

*What are your favourite aspects about this area?*
The beach, my house, no trains, the people, the makeshift tents on the cliffs, sculptures, Flickerfest (local film festival) and the way my view from work is different every day.

*How do you see Bondi changing over time?*
It will be a challenge. In St. Kilda (Melbourne), the backstreets, the darkness and the mystery, were almost driven out by developers. What made St. Kilda almost die, let's not let that happen to Bondi. I believe that Bondi will go through massive development, let's just make sure it is good development because that is what is important – everyone's quality of work – and let's continue to make this the best inner city beach in the world.

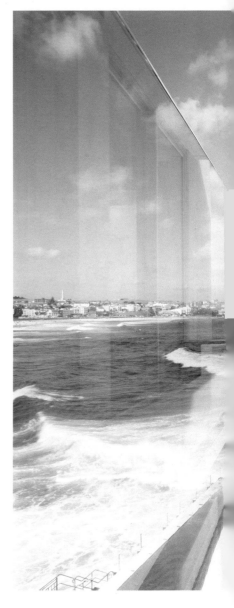

I still like a late

…iT HAS GiVE

NORTH BONDI ITALIAN

NIGHT DRINK BUT I HAVE BEEN EXPOSED TO THE

BEAUTIFULLY DAYTIME ENVIRONMENT OF THE BEACH...

ME A GOOD BALANCE IN LIFE.

# EUGENE TAN

### PHOTOGRAPHER
### & WEBSITE / GALLERY OWNER

A local newspaper proclaimed: 'Eugene Tan has the best job in the world,' which may explain the Perth-born surfer's sunny demeanour. This photographer, website creator and gallery owner has combined his great passions in creating surfing institution 'Aquabumps'.

*Where are you from originally?*
I grew up in Perth, Western Australia. I moved to Bondi when I was 22 years old. I gravitated to the Bondi area for many reasons: The ability to enjoy the ocean so close to a business centre (Bondi being eight kilometres from the city centre). You can surf before work, work a 10 hour day, surf after work with daylight savings...incredible! The landscape is so beautiful, dramatic and interesting – unlike the dead straight beaches of WA. You can live metres from the water's edge – real estate is not that close in Perth. My first apartment here was 30 metres from breaking waves – I just couldn't believe this was possible in Australia. Lastly, the people mix that makes Bondi unique. Bondi's people are so diverse – anything goes. I like that.

*What is Aquabumps? How did it come about?*
Aquabumps is a photographic journey through modern day surf and beach culture. Aquabumps has two faces: the gallery where fine art prints are sold and the website which provides a two minute escape for thousands of deskbound office jockeys who would rather be at the beach.

Aquabumps came about through the combining of three passions – surfing/beach, photography and online design. In '99 digital cameras became remotely affordable. I'm still talking the $12k range for even the most basic model which was two megapixels. The immediacy of shooting an image and to upload it online in seconds for thousands of people to view just blew me away. I realised I had to take advantage of this new digital medium.

Also at the time I was working in an online design firm, Eclipse Group, as their Creative Director, being exposed to the latest advances in that whacky thing called the 'internet'. Bulk emailers evolved where you could send thousands of emails all at once – for 'free' for me at the time as I worked in the business. Rad. So it just made sense to take imagery of Sydney's beautiful beaches and then pump them all over the globe... from there it just grew and grew.

Everyone gave me their email addresses to add to the list as this is before the days of SP*am. Now 30,000 people subscribe.

The ocean has always been a passion for me; I have spent every spare moment since childhood immersed in the ocean whether diving, surfing, skiing or wave sailing. This love of the ocean has driven me to shoot pictures whilst swimming in the waves – getting angles that not many people see every day.

*Where are the photographs taken?*
Bondi mainly; in, out and under the water. I do travel overseas around eight times a year to Tahiti, Fiji, Indonesia, the Maldives, Samoa, Chile. I also go up and down the New South Wales coast. Basically wherever there are good waves and photogenic coastlines.

*Where can we see your work?*
Aquabumps Gallery, 151 Curlewis Street. The walls of Commonwealth Bank's offices. Wallpapers on Telstra's mobile phones. Magazines (Tracks, Photoreview, Madison).

*What is unique about it?* Unique angles shot from within the water and underwater. The format in which it is presented – acrylic framing techniques.

*What have been the best surfing spots you've been to locally and internationally? Best photography locations?*
Locally, South Bondi on a clear water day, Tamarama mid-winter after a big south storm, Maroubra on a big swell. Internationally, Mentawai Islands in Indonesia and Teahuppo in Tahiti.

*What are some of the more unusual subjects/places/events that you've photographed?*
A huge whale at Bondi in August 2008 (which came in real close to surfers). Underwater nudes at Mackenzies beach, Tamarama for Mark Vassallo's BONDI book. Last week when Bondi was tubing like Hawaii's pipeline which is rare. Drunk backpackers at sunrise after a big night on the turps.

*Do you plan to open any galleries elsewhere?*
Maybe northern beaches of Sydney, Bangalow near Byron Bay, the US and UK.

*There are many beaches in Sydney and in Australia; what do you think distinguishes Bondi from the others? Why do you think it has become so famous?*
It's the mix of people. It's the vicinity to the city. It's the history of the place. The old diggers at Icebergs, the stories of AC/DC playing at the Astra, the gay community in the north end, the tourists in the middle, the big sunnies on the grass in the north, the Brazilians playing bat and ball in the south – it's the lot – all mashed into one beach.

# NICK

37

## SALES REP.

Darko shorts and tee and Spring Court canvas hi-tops.

When I used to come to the markets years ago I came for people who were selling their own secondhand things. Clothing, accessories and vintage bric-a-brac – vases, paintings and stuff. It was nice – you could get something glamorous at garage sale prices. That's still the case and now a lot of people with young fashion labels also use it as a vehicle.

# EVA GALAMBOS

## BOUTIQUE OWNER,
## PARLOUR X

As someone with their finger on the
city's sartorial pulse, Eva Galambos was
chosen to be Sydney's local rep for the
Wallpaper guide. Travelling the globe
to stock her stores, the third generation
Bondi resident is owner of exclusive
fashion boutique, Parlour X.

*You're a true Bondi local – what's your
family's history here?*
Both parents were born abroad and when
they arrived to live in Sydney, separately,
at very young ages, Bondi Beach is where
they headed first. Our family has lived in
Bondi for over 50 years.

*How did you come to start your boutique
Parlour X?*
I was a wholesale fashion agent for 10
years before I became a retailer and it
seemed like the natural progression for
me, at that stage and time in my life.

*What are your favourite Australian
fashion brands?*
Michelle Jank, Kirrily Johnston, Camilla
& Marc, Marnie Skillings and Josh Goot.

*You said "Bondi is to Sydney what the
Marais is to Paris and Soho is to New
York" – what characterises it as such?*
Bondi, the Marais and Soho are like
microcosm societies that reflect self
containment, that blend past with present
and stretch beyond notions of wealth. It's
a melting pot of people from travellers
through to creatives to locals.

*How do you think this came to be?
When did Bondi adopt this character?*
Bondi has always been a melting pot like
(Sydney suburbs) Surry Hills, Darlinghurst

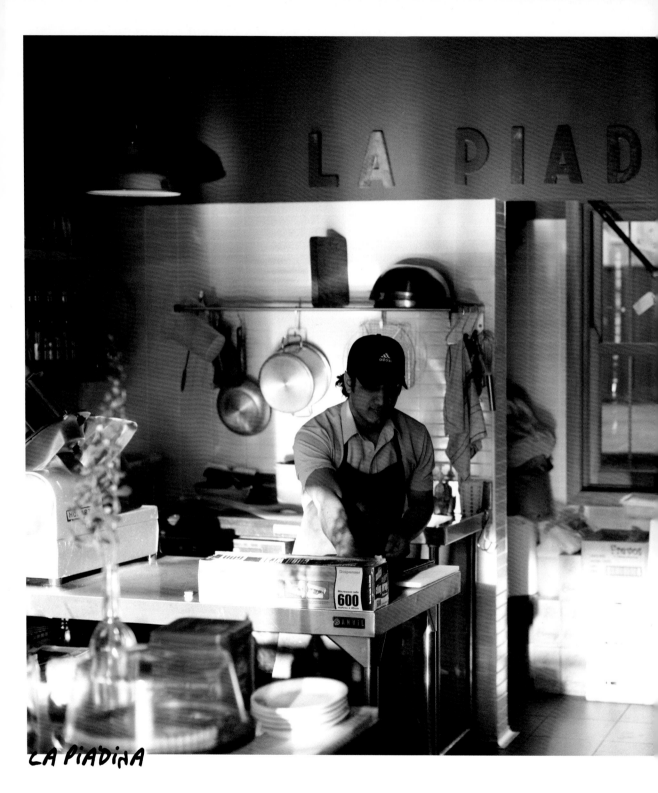

LA PiADiNA

and Elizabeth Bay; with seedy undertones because there is a blend of immense wealth mixed in with homeless and backpackers and families crossing many nationalities. You hear many languages walking the streets, hanging out in cafes and sitting on the beach.

*How do you foresee it developing in years to come?*
I think the sprawl of wealth will gentrify Bondi to an extent. I like the fact that this input of wealth will hopefully see Bondi become less dirty and improve the general appearance and aesthetic of the homes/ buildings and commercial exteriors.

*What do you think it is about the area that draws so many creative and fashionable people?*
It's the closest beach to the city… the beach living and beach mentality. Laid back 'café culture' and holiday lifestyle seem to go hand-in-hand with creative types who use their environment to draw inspiration.

*What differentiates a 'real local' from a transient Bondi resident?*
Someone who has lived in Bondi for many years; to have lived and seen the major changes that have shaped Bondi into what it is today – someone who remembers the difference from before. Someone who actually considers themselves a local.

*What are your best tips for things to do or see, which the average visitor probably wouldn't uncover?*
Not telling… Try the Bondi to Bronte walk.

*Where is your favourite place to:*
*Have breakfast?*
Luigi's or Jed's.

*Have lunch?*
Outdoors: North Bondi grassy knoll with a takeaway juice – but not in the heart of summer – it's too crowded! Indoors: La Piadina on Glenayr Ave.

*Have dinner?*
Casual: Rawbar or North Bondi Italian. Chic: Icebergs.

*Have drinks?*
Casual: Flying Squirrel. Chic: Icebergs.

*To shop?*
Bondi Markets.

*How do you think living in Bondi affects your work and your life in general?*
If I don't have to work on the weekends, hanging out in Bondi without even getting in the car over the two days, makes me feel on Monday as though I've just been on vacation or away for the weekend.

Living by the beach in an area where most of my friends and all my family live is the best thing ever. If I am not working, I can wake up on Saturday morning, not have made a single plan for that day and by the end of it I've already had breaky, lunch and a few coffees with separate friends, I've walked the dog along the beach, I've played with my niece and nephew and maybe even squeezed in a massage. By nightfall, I've bumped into so many friends, that I've been invited to parties or low-key dinners hanging out at friends' homes or dining at any number of favourite local hangs - only to awake on Sunday and do it all again but this time throw in the Bondi markets and maybe have a tarot reading.

## ELISE

29

### CAFÉ / FASHION STORE OWNER

## JACQUELYN

34

### CAFÉ / FASHION STORE OWNER

I'm wearing an Ellery top, Illionaire pants, vintage earrings and Melissa shoes.

Ellery shorts and top; vintage belt and shoes.

We came up with the idea for the cafc/store while living in London. There were a few shops like this which mixed fashion with a café. We especially liked one in Shoreditch called 'No-One,' – they stocked a lot of Australian and New Zealand labels, which is what we do.

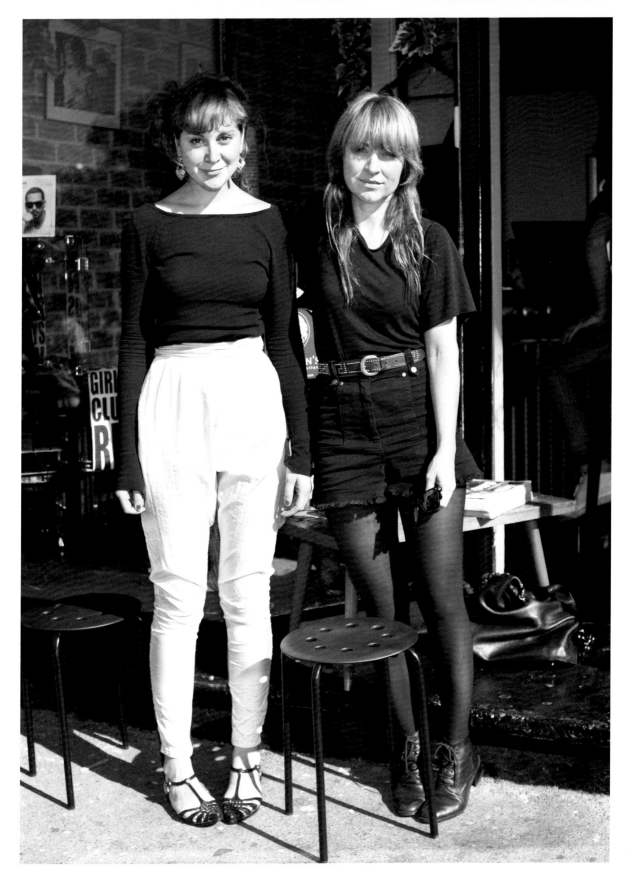

# SCRAP

28
**ART DIRECTOR**

I'm wearing Ray-Ban sunnies, a Louis Vuitton necklace, Bassike top and pants, Demeulemeester shirt and Common Projects shoes.

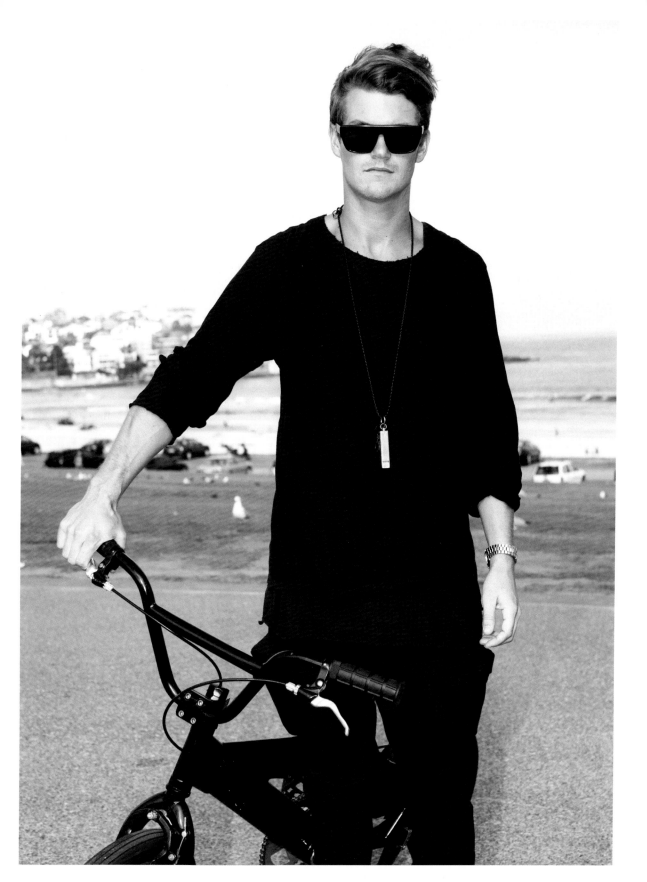

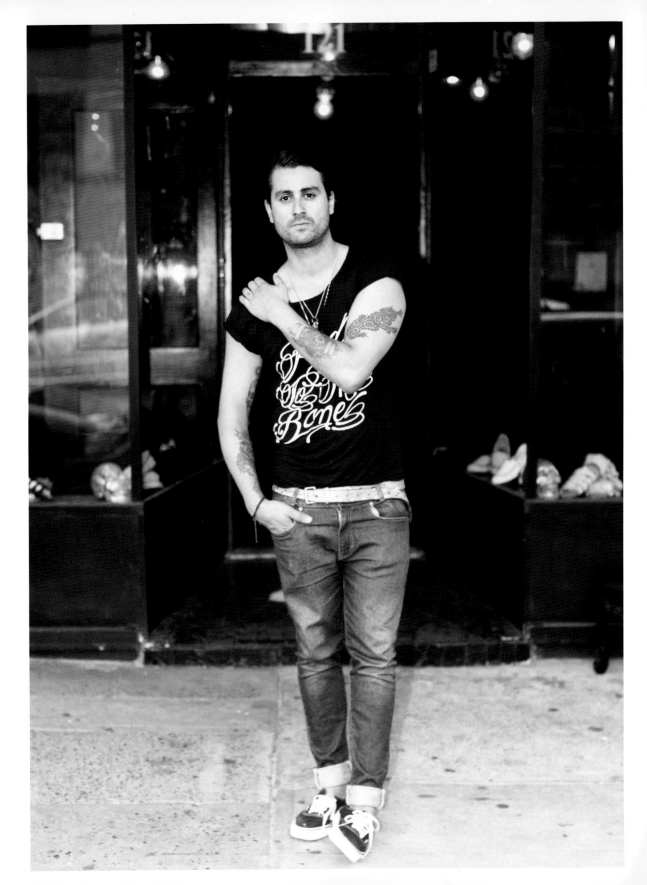

# DANIEL HERNANDEZ

### DESIGNER, DARKO

Daniel Hernandez is a fashion designer and artist, whose preoccupation with the 'dark side' gives his work an edgy, gothic feel.

*How long have you lived in Bondi?*
I have lived in Bondi for more than 10 years on and off, but I always call Bondi home. It's just the best beach worldwide... the east coast is simply beautiful.

*What was your path to creating your fashion label, Darko?*
The label was created while I was freelancing for a pile of labels (I have designed for Insight, Mambo, Dunlop, Illionaire, Something Else and other labels) and not feeling able to do what I wanted to do creatively. So I just decided to start my own label – one which reflects my character. It embraces the dark side with a romantic and elegant undertone.

*How did you come up with the name?*
It started years ago, even before the actual film Donny Darko. In Australian culture when you're hanging with mates, names get abbreviated such as Dave becomes Davo, Steve becomes Stevo. Well with my mates I am known to be quite a dark character so they used to call me 'the darkness' and it evolved to become Darko.

*Which came first, the art or the fashion?*
The art came first – I've been doing art from about age six.

*Where does your inspiration come from for your art?*
Comics, cartoons, art history books, modern art and album covers.

*You seem to have a preoccupation with the 'dark side' - symbols of which are shown in your art and clothing.*
It just seemed natural to me to be interested in the dark elements of life. While arguing with my family as a child I once wrote in my diary that 'two negatives make a positive' and I have always thought that dark elements within emotion, colours and life balance out the bright sides. Fashion and cultures seem beautiful with these contrasts balancing both ends of the spectrum.

*How does this darkness sit in a beach culture like Bondi?*
Bondi has an amazing, diverse culture as the area has all walks of life. As a collective, people here are pretty free-thinking, so all kinds of culture fit.

*Is there a dark side to Bondi?*
From living here I have noticed that Bondi has a dynamic dark side that even shines when it's the sunniest of days. Bondi has a very ying yang environment - the locals and the tourists enjoy it for its good and its bad.

*How would you describe Bondi style?*
Bondi style ranges from classy to assy; from street to bleak. Everything from super relaxed styles to an ultra suit vibe. There is a laid back crew and hippy crew and then there's the coffee boho style.

# SAM

31
## MARKETING MANAGER

I'm wearing a Critical Slide Society tee, vintage army shirt, Nudie jeans and Tretorn shoes.

A summer weekend in Bondi all about words starting with B: beers, babes, banana smoothies, bogans, bandanas, burritos, banks, Beach Rd, budgies vs. boardies and bonking.

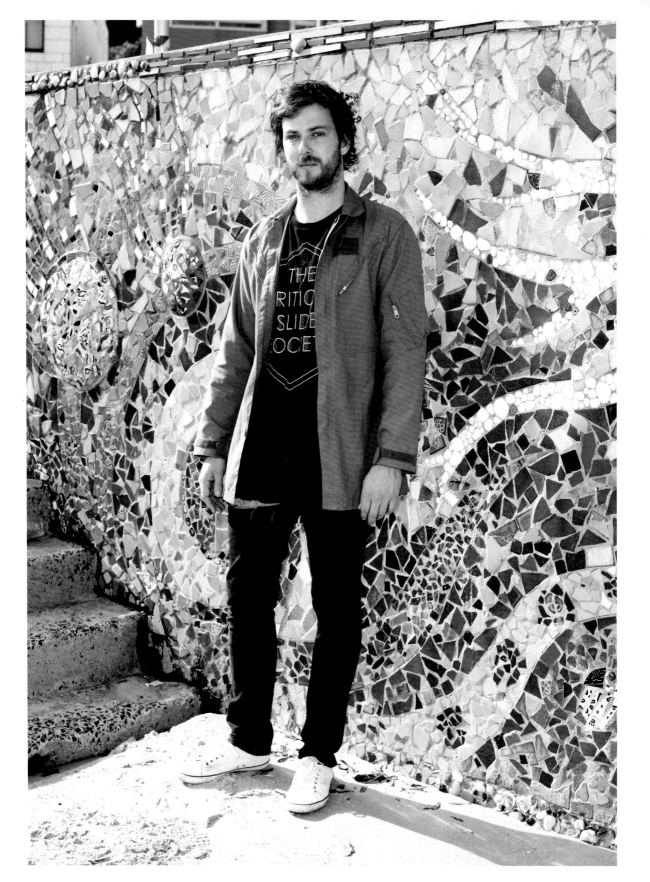

# BONDI

# PEOPLE

ARE SO DIVERSE... ANYTHING GOES, I LIKE THAT.

EUGENE TAN, PHOTOGRAPHER

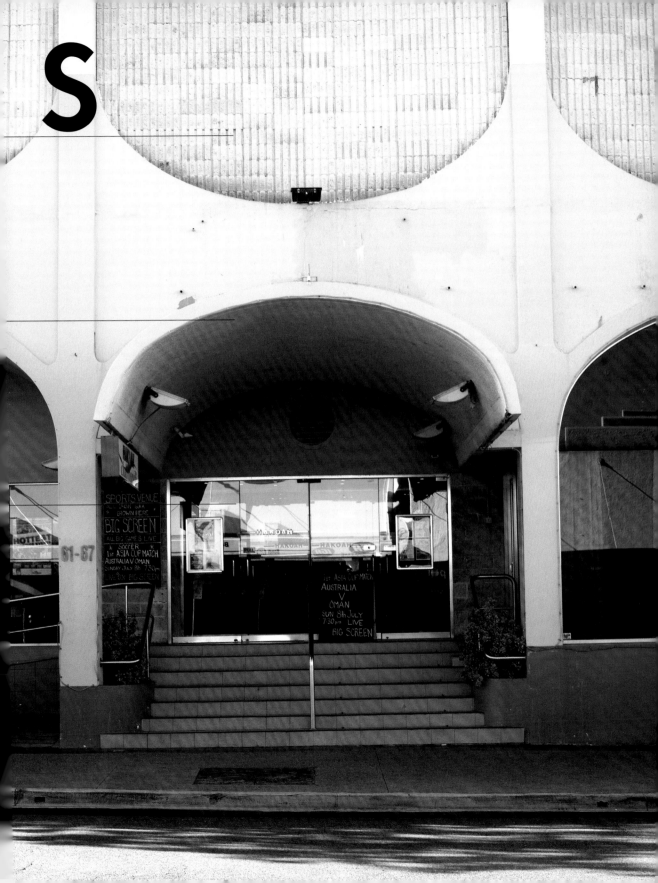

# OSLEM ESEN

## MUSICIAN & FASHION
## DESIGNER

Fashion designer and band
frontwoman Ozlem Esen is known for
her unmistakable style. Her beachside
home is a treasure trove of collectables,
representing her two great creative
passions - music and fashion.

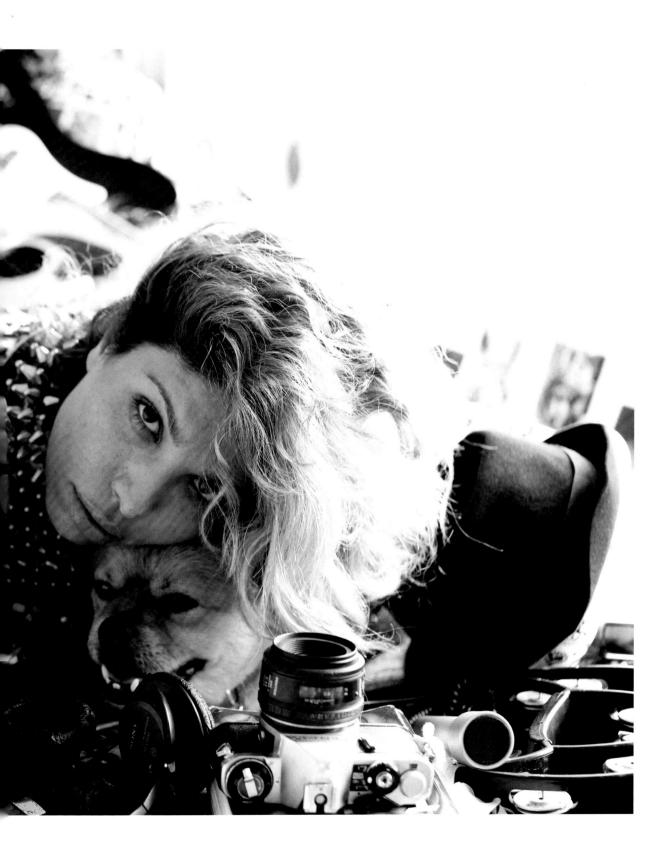

*You've lived in Bondi for 15 years – what changes have you noticed in that time?*
Bondi has changed so much, it's crazy. Campbell Parade still spooks me when I walk past KFC and all the tourist shops. It feels like Hermosa Beach on steroids. It's definitely more crowded. The rocks, the grassy knoll - they were not really the places to hang out. Now it's hard to find a place to sit. A lot of the old faces have been replaced with what seems to be a younger breed of cool crew than that of the organic crew of the past.

Years ago it was a smaller group of creatives that would have dinner parties and house parties. That definitely still happens here but on a much bigger scale. Obviously there are more restaurants and places to have a drink and more shops. I remember when there was one shop to buy an outfit and only a couple of cafés to hang out in.

The Beach Road was really the only place to go out. A small pub with candles burning on the bar and live bands - a place where all the locals met up. Everyone had their own style and attitude. No matter where you went in the world, it felt as though the style people had here was unique and pushing the boundaries.

Bondi was not on the map as such back then but now it's one of the most well-known beaches in Australia, if not the world. It is known as a breeding ground for creatives of all kinds. I feel that everyone here is pushing to get their art and talents acknowledged. I personally think it's a launching pad to the world.

So many Bondi people are doing amazing things worldwide and are being recognised for their work. It's almost a melting pot of like-minded people in a family unit; all collaborating on pushing their art collectively. How many musos, filmmakers, fashion designers, photographers and stylists do we have around us? I see young kids who move here from small towns. They're shy at first, but you know they have something special in them. It's great to see them come into their own, dressing in crazy outfits and having the opportunity to work in areas in which they otherwise would not have. I feel Bondi instills confidence in people.

No matter where I have lived in the world I still feel like we are the only place where it's an extended family unit of friends. "The orphans" family unit I like to call it. Everybody knows everybody, which I think is great. You can leave your house with no phone and no shoes at 9am, and hang out all day with a number of different people till dusk.

*During what period did you most enjoy living in the area? Why?*
Hmm, maybe during the Beach Road candle days. Everything was more organic and newer to me. Everyone seemed so cool and confident to this new girl in town. We had a small, tight gang who did everything together, whether it was the beach or breakfast, dinner or a trip out of Bondi (God forbid!). It was our gang. We would put on house parties and would DJ and jam all day long.

I can still picture the hundreds of people who paddled out to sea to form a circle and join hands; the unity of friendship was beautiful. I guess it's still the same, just that we are older and have less time to waste.

*You have an amazing collection of clothing and art: what are your most treasured pieces and what are the stories behind them?*
Oh there are so many pieces I treasure! I'd say my grandmother's hat collection.

I FEEL BONDI inSTills conFiDENCE in PEOPLE.

She wore elaborate, over-the-top hats which is where I think my obsession with props comes from. They are individually kept in beautiful old hat boxes. Also, a ring a friend recently made with his hands, it's amazing; and the photo my favorite photographer of all time, Ellen Von Unwerth, took of my best friend and me in LA. I have it on my wall; it reminds me of her and fun times.

My vintage cigarette case Fatima Robinson gave me. The jacket my friend Ali handmade me that I'm wearing now. Just recently she sent me a package from London full of things she made for me. It gave me hours and hours of Christmas-style fun. She is the most creative goddess ever. My dad's AKAI microphone I have had since I was 8 years old. My vinyl collection, my book collection, my first ever underwater shots collection, my sunglasses collection, old photos of my family tree...

I'm so lucky I receive a lot of gifts from my talented group of friends that are handmade. They are the things I worship and treasure. It may be a drawing of a scribble or an incredible piece of jewellery from Michelle Jank, but I love them all equally.

*What are you up to at the moment with your band 'O'?*
My band's back with an amazing crew of musicians. Our drummer is a crazy cat from LA, who is watchable all on his own. We do our second film clip in Byron soon and hopefully start playing in the not-so-distant future. We are having so much fun right now just playing for ourselves; I can't wait until we play for friends.

*Who and/or what are your musical influences?*
Oh man, that's a hard question. Everything from Dave Brubeck to Prince, Boney M, Cat Stevens, Patti Smith, Modern Lovers, Lani, Young MC, Tribe, Nenah Cherry, Bumblebeez81, Biggie, Minnie Ripperton, Radiohead, Jill Scott, Mason Jennings, the Beatnuts, Jungle Bros, Nick Cave, Television and anything old-school, hip-hop, reggae.

*iPod, CDs or records?*
Vinyl, vinyl, vinyl. First off I don't own an iPod anymore so CDs it is.

*How would you describe your personal style?*
It changes every day according to my mood. I go from pretty to tomboy to glossy to slick to hip-hop on any given day, but generally it always has a touch of tomboy-ness to it. I am obsessed with props of all kinds - I love a good one-off piece that's slightly over the top. I love pushing my limits on what I feel I can get away with.

*Does your style change if you're in a different city? How so?*
So much so. Tokyo is the opposite of getting dressed and taking something off - it's more, more, more. You can wear anything and nobody will judge or even turn back for a glimpse. That is like a ticket to freedom for me, in props of the over-the-top kind. Bigger suitcase required here!

Turkey: tone it down, class it up. Bring your labels and don't stand out unless you want to be gawked at and get extra attention from the wrong people. London and Berlin brings out the one-off dark side in me. I like wearing black, ripped, layered, one-off pieces. LA is so casual, you feel like you're really trying if you dress up. The understated t-shirt and jeans look is about it. My girlfriends are all about low key, but hell, they are so gorgeous they don't need anything but a smile as a prop. Paris is a ticket to chic le chic, feminine, sexy pieces.

*You have quite a few creative pursuits; what are your future plans with your two main passions: music and design?*
To have more and more and more fun. To not worry about where each is going and to just enjoy every second of the moment with the crazy, clever people I am so lucky to be working with. To continue to work with my good friend Fatima Robinson on our one-off creations ranging from sunglasses to jewellery to bedding to books.

To branch out into the different areas of work I've been diving into lately and hopefully tie it all together with a big fluorescent bow.

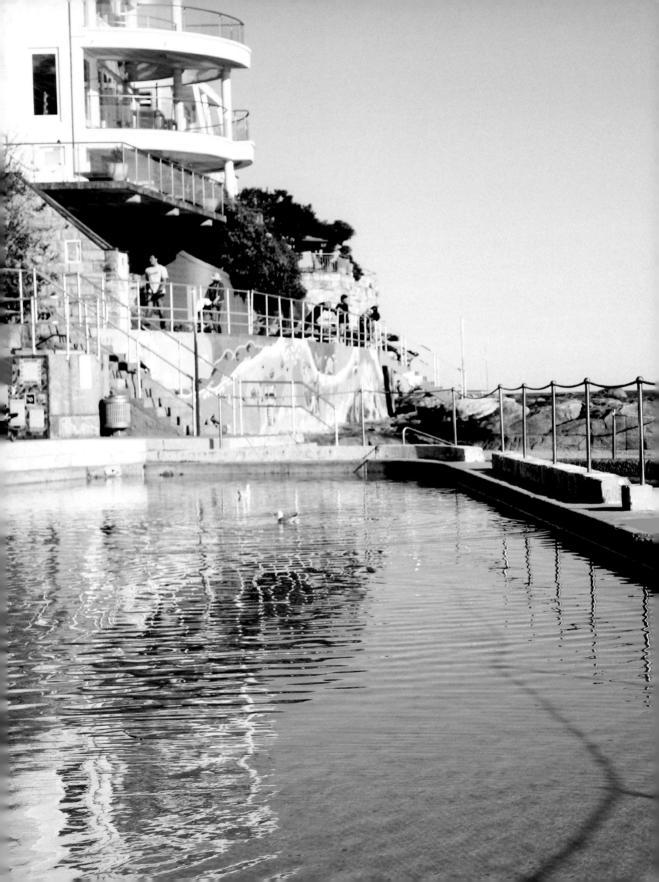

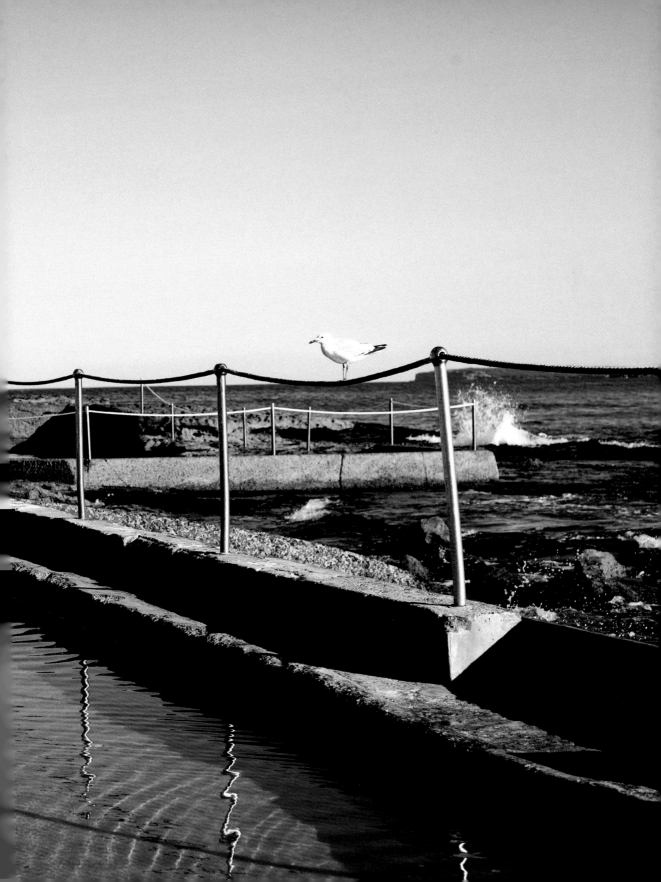

# THE LO

# OF

# BONDI

*A MILKSHAKE OF GOOD-LOOKING PEOPLE HAVING A GOOD TIME*

FERNANDO FRISONI, DESIGNER AND FASHION COLUMNIST

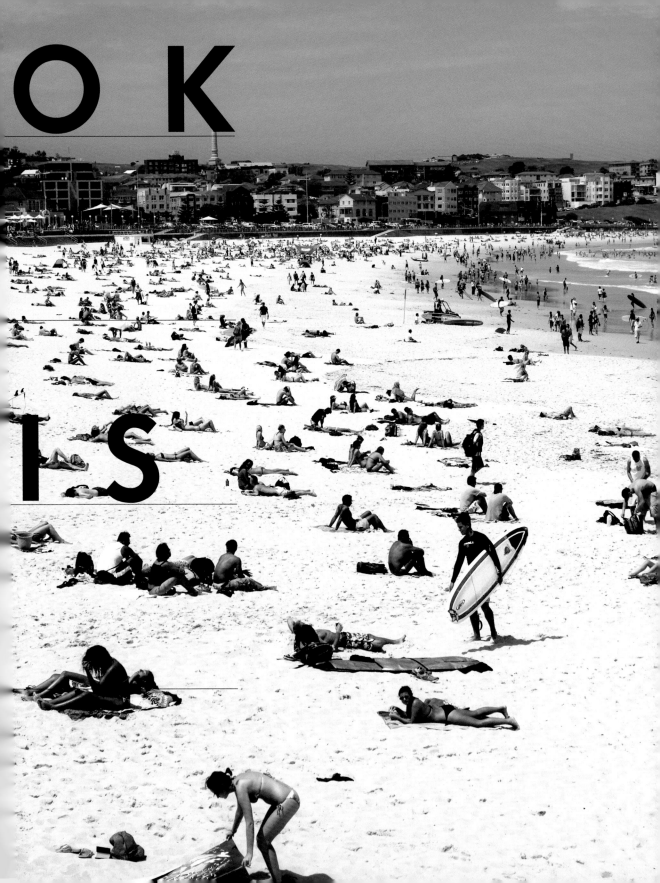

## KATIE BOYD &
## TANIA RICKARDS

### DESIGNERS,
### THE CASSETTE SOCIETY

They could be a modern take on the
girls in Madonna's '85 classic
Desperately Seeking Susan. 80s addicts
Katie Boyd and Tania Rickards flavour
their quirky fashion label with references
to bygone eras and their trademark
bubbly personalities.

*How do you know each other?*
KB: We met through a patternmaker
who we both work with. That was
the beginning of our forever fruitful
relationship.

*How did you come to work together on
Cassette Society?*
TR: Katie had started doing Cassette
Society earlier that year through another
business; the guys she was doing it with
decided that she should go it on her own.
My husband and I had set up a sales and
distribution company around the same
time. Katie came into the office to chat
to us about what we could do to give the
brand a new lease on life. Admittedly,
it was love at first sight and by the end
of the conversation we decided to go
into partnership with the label. At first I
thought I would be working on the label
as a side project to the agency but within a
few months it became all-consuming.

*Where did the label's name come from?*
KB: It's 80s driven. Cassettes reigned; the
music was insane back then. We wanted to
tie a reference to this into the branding, so
that's how it came to be.

*Who is your typical customer?*
KB: The demographic is roughly 15-30
year olds. There also has to be at least a
mild appreciation for the 80s to get into
our label. Cassette girls are normally quite
fashionable, somewhat daring
and liberated.

TR: Girls who appreciate fashion that is
directional while still being wearable. We
find our bestsellers are always styles that
have a pretty and an androgynous combo
going on. This is obviously the type of girl
we appeal to.

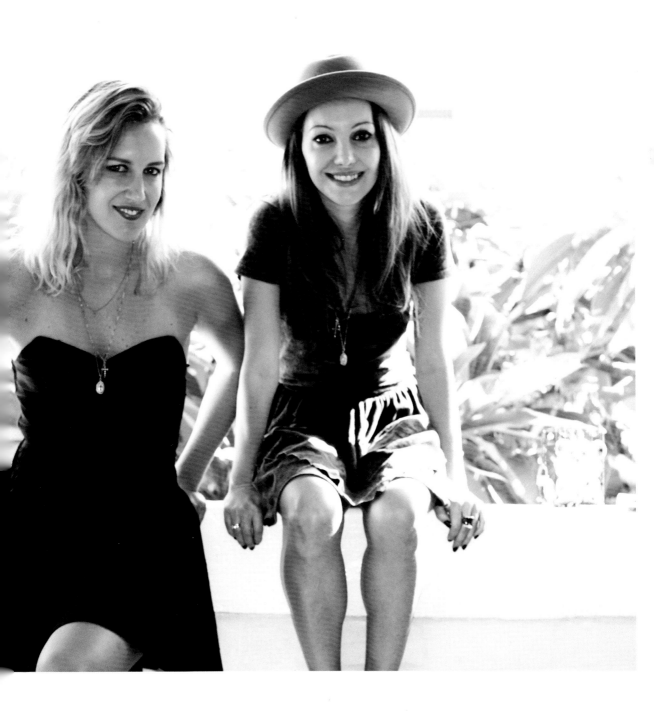

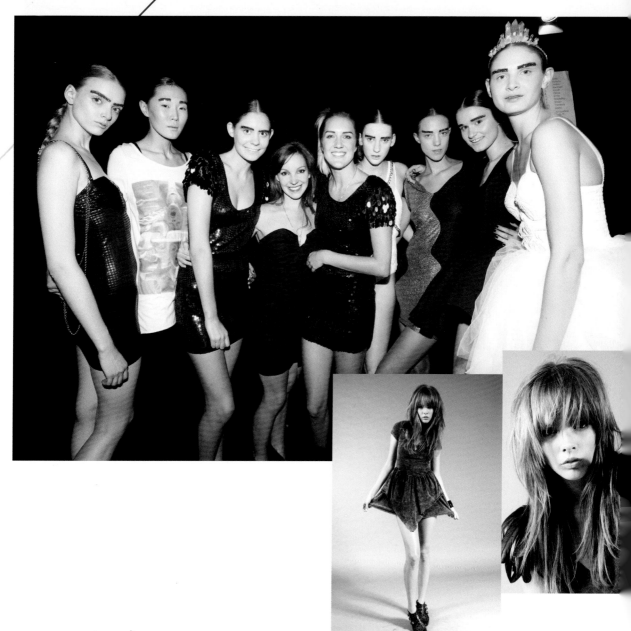

AUSTRALIAN FASHION HAS SUCH A RELAXED,

LAID-BACK YET SOPHISTICATED LOOK.

*What was the path to get the label to where it is now? Was it difficult?*
KB: It's been an excruciating but rewarding path to say the very least. Tania and I have worked incredibly hard over the last two years together and it's just now starting to really show.

TR: The beginning was really hard - we had no income for the first six months. We had to work to get customers to give a new label a go. We had to beg and plead with our suppliers and manufacturers to produce our teeny orders. There were times we were so close to giving up, but we stayed positive and kept giving it our all every day. Every few months things got a little easier, our orders increased a bit more, our systems became more refined. Both our partnership and our label are continually evolving.

*What do you think are the quintessential items in the 'Bondi wardrobe'?*
KB: Some groovy eyewear, Havaiana thongs, chains and bracelets and a current jewellery 'must-have' - the Abbey Lee (Australian model) sleeper earring through the nose! Ha ha, seriously they are getting coverage! Oversized tee dresses for draping at the beach and beyond.

TR: Good quality basics (singlets, tees, tee dresses); ripped, cut-off denim shorts and a selection of sexy summer dresses that can be worn day or night. A good leather vest or cropped leather jacket and then awesome accessories to dazzle. Studded or fringed leather bags; Cassette Society studded sandals for day and Cassette Society 'Lil Booties' for night. And eyewear - look out for the Cassette Society/ Sabre Vision collaboration.

*Do you think your label has a 'Bondi look'?*
KB: I guess yes. Our look's universal but there are plenty of Bondi groovers that love a bit of 80s translated.

TR- I definitely think our label has a Bondi look. We have both lived and spent so much time there so I guess this is evident in our collections.

*You sell in Japan; how do you find they receive Australian labels?*
TR: We just sell to the one store in Japan and the sell-through is great. I think the Japanese market receives Australian labels in a really positive way. They like our casual, sexy look. I think they appreciate the quirkiness that a lot of Australian labels have.

*What is unique about our fashion industry?*
TR: Australian fashion has such a relaxed, laid-back yet sophisticated look. Our love of the outdoors really shows in our fashion. The growing demand for Australian labels overseas is proof that the rest of the world aspires to this too.

*Do you have any Bondi shopping tips – what to buy and where?*
KB: Go to The Fruitologist for fresh fruit and veges, The One that Got Away for seafood, Sushi Love for Japanese, North Bondi Italian for drool-worthy Italian and atmospheric sunset drinks and Gelbison for zuppa di cozzi (mussels). General Pants Gould St for the latest in fashion. For vintage, there's always a garage sale. For massage, One Fine Day on Bondi Road. For a smoothie or bircher muesli in the sun, Icebergs' pool café.

TR: Swimwear from Jatali (Gould St); restaurants - Sean's Panorama and Bondi Trattoria. Books from Gertrude and Alice.

*Where do your ideas for new collections come from?*
KB: Movies, music or books usually. For example our latest collection is called That Heroine's Electric. This all came

about when we were watching 60s sci-fi film Barbarella. This film's hilarious, sexploiting heroine Jane Fonda, helped create a starting point for the collection's theme: heroic dressing. Cassette Society is always influenced by the 80s, so we wanted to create our take on sexy, heroic, power-dressing fashion. 80s and power-dressing is all the hype right now. So 80s silhouettes, floral prints, wet-look fabrics, acid washes and then our prints relating back to the Barbarella film storyline. For example, the 'galactic phallic bananarama' or the 'earth creeping' print.

TR: We tend to get excited about something in particular – like Katie said, music, movies etcetera and then research to find out more info about whatever the theme is. We do a lot of late night phone or email sessions while we are both on the net finding stuff and getting really excited. Our current collection has come together so well as we started with the whole 'Barbarella' theme months ago and it has eventuated into a collection that is all about power-dressing…strong women with elements of raunchiness with our bustiers and acid washed minis.

*What music are you into at the moment?*
KB: Right now it's Radiohead 'In Rainbows'. Doesn't matter if this album's on repeat for a day; I never get over it. Tame Impala for sexy, surfy sound; The Whitest Boy Alive, CSS (Caseidesersexy), Crystal Castles, Bumblebeez, Ghostwood, Interpol, The Presets, The Horrors, Kings Of Leon, Whisky a go gos, The Prodigy, Nirvana, The Cardigans, Transvision Vamp, TV on the Radio and Björk.

TR: Ditto on Katie's The Whitest Boy Alive, The Presets, The Prodigy. We are also listening to a lot of Rolling Stones, Beatles and Public Enemy of late.

*Who are your style icons?*
KB: Everyone's getting tired of the over-exposed Agyness Deyn but she truly dresses exactly how we like girls to look. She is a paradox of feminine and masculine. Her outfits are always executed with such zest and signature flavour. I also enjoy Erin Wasson and Daria Werbowy's interpretation of sexy, cool, staple dressing.

TR: Anita Pallenberg, Marianne Faithfull, Jane Birkin. Madonna in Desperately Seeking Susan - her outfits were insane! Kate Moss always nails it.

## AKILA

31

PHOTOGRAPHER

## ANDREAS

28

CHEF

Levis shorts, clogs from Sweden, vintage top and bag, necklace from Thailand.

With my style, I draw inspiration from my girlfriends who've lived here for a long time – their laid-back, 70s look.

Vintage Harley Davidson tee from Hawaii, Ksubi corduroy jeans, Vans shoes.

I often come to the boat shed here for picnics – it's the best to swim off the rocks.

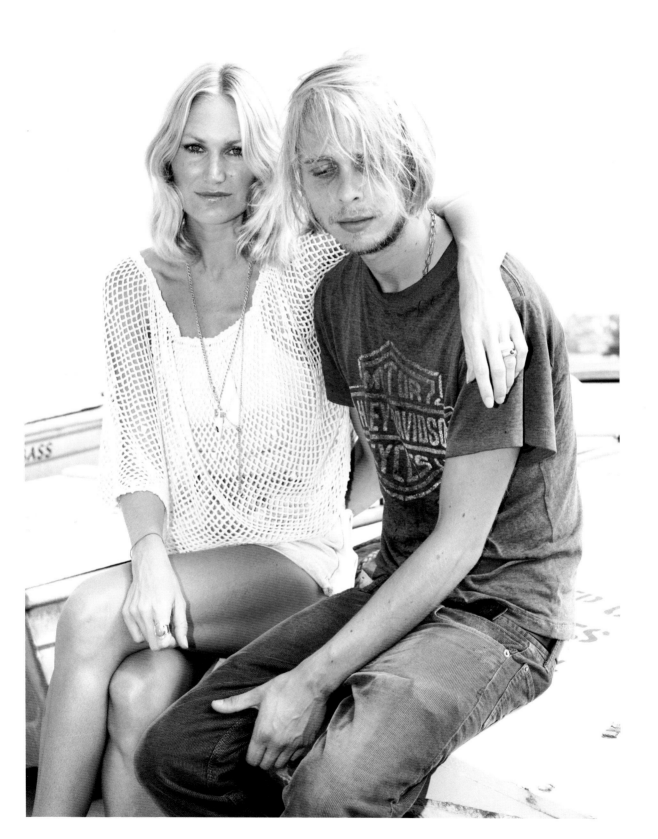

# SOPHIE

19
**TRAVELLER**

I'm wearing Ksubi shorts, a COS top, American Apparel sunnies I got in Berlin, Minnetonka shoes from my home town Copenhagen, a bracelet from India and a Marc Jacobs bag.

I'm definitely going to come back for summer here. People are more calm here; down-to-earth. I love that for people here, no dream is too big.

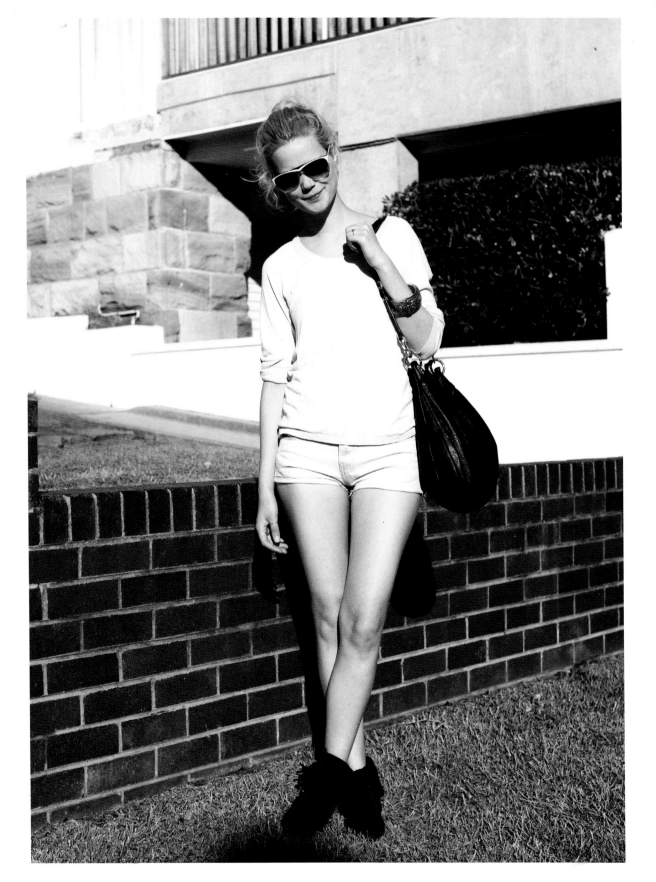

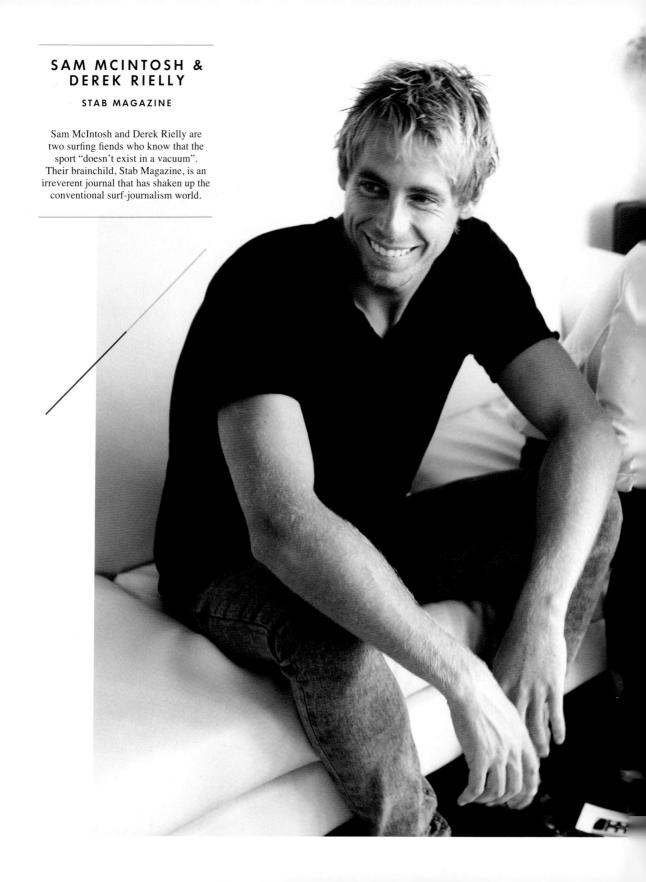

# SAM MCINTOSH &
# DEREK RIELLY

## STAB MAGAZINE

Sam McIntosh and Derek Rielly are
two surfing fiends who know that the
sport "doesn't exist in a vacuum".
Their brainchild, Stab Magazine, is an
irreverent journal that has shaken up the
conventional surf-journalism world.

*How long has Stab been around?*
Five years.

*How and why did you start the magazine? What were you doing before that?*
We published a couple of books and decided to murder the proceeds on a magazine. I'd been sacked from another surf mag and Derek was editing a porn title.

*Who are your readers?*
We hope it's a sophisticated surfer who represents a cultural bulwark against the surfing norm, but it's most likely someone who just likes the nudity in most issues.

*What sets Stab apart from other titles in the same genre?*
Poor profits and an inability to stick to a budget if we like an idea. Surfing doesn't exist in a vacuum - we try to illustrate that.

*What portion of the content is locally derived?*
A little. We're an international title created in Australia but when local content is world class, we'll run with it. Local surfer Perth Standlick is a regular.

*How often do you surf? Whereabouts?*
Four or five times a week. Sometimes in the eastern suburbs. And there are some good reefs nearby. Failing that, Sydney has the world's best situated airport.

*Is Bondi a good surf beach?*
It's good because it's got atmosphere and it feels alive. Nowhere in Australia has such a cross section of beachgoers. Geographically, the best thing about Bondi is that it's relatively protected from the prevailing (north east) summer wind that plagues most beaches on the east coast. And, it's open to all the south swell. Please forgive the surf talk, I could go on about fetches and the like but I've got a stilnox if you'd prefer that.

*How about for inexperienced surfers?*
It's a good beach for a beginner. It's good for anyone. The more, the better. A good way to approach a surf at Bondi is to expect nothing. If you get something beyond a rolling of your arms, then you're a winner. If you don't, then you should've known better.

*Where's your ultimate surfing location?*
Australia is incredible in its variance of breaks. Even the east coast of Australia. I love Hawaii, Tahiti and Indonesia: all the clichés on tap.

*In what ways do you think surf culture has had an influence on Bondi fashion and culture?*
More than an influence on surf fashion I think Bondi's a place where anyone can dress how they feel without fear of being ostracised.

*What are your future plans for the magazine?*
I can't wait for the day when we stop the theatre of printing magazines and it's all published online. Creating a story and then waiting six weeks or more till the world sees it seems archaic.

alive.

BEACHGOERS.

STAB MAG

# STEVEN PAVLOVIC

## MODULAR RECORDS

Steven "Pav" Pavlovic is founder and director of international record label Modular, which represents many of *the* names in the music industry right now: The Presets, Cut Copy, Ladyhawke and Van She, to name a few.

*What does your company do?*
Anything and everything with any kind of questionable link to good music.

*What is your background in music/ business?*
I started out managing bands, then booking local venues around Sydney and then moved into promoting tours for both local and international bands, some of which included Nirvana, Pavement, The Beastie Boys, Beck, Smashing Pumpkins, Green Day and a host of others.

*How did you start Modular? What was it like in the beginning? How has the business transformed?*
Modular came to life in '98 when I was receiving lots of demos from local bands that wanted to play with the international acts I was touring. I received one that was so compelling I decided to form a record label to put it out. That band was called Quentin's Brittle Bones, who later changed their name to The Avalanches.

In the beginning the label was a hobby and an adjunct to my touring business. With the commercial success of debut albums from The Living End, Ben Lee and The Avalanches I developed the confidence to focus solely on the recording part of the business. Over the next decade I signed lots of great local and international artists including Cut Copy, The Presets, Wolfmother, Jack Johnson, The Yeah Yeah Yeahs, Van She, Ladyhawke and Tame Impala.

Creatively not much has changed, people still send me good music and I still say 'yes'. Commercially a lot has changed! People prefer to say 'no' to buying music legally and 'yes' to downloading it illegally. As such the label has become a hobby again and I focus mainly on the other areas of my business that have expanded to include a touring company, a talent booking agency, a new media/ marketing agency and a merchandise company.

*Was there a defining moment/period when things took off?*
I don't know if there was a singular defining moment, more a series of opportunities that I said yes to. When I started promoting concerts I met the guys from Nirvana and asked them if they wanted to tour Australia. They agreed. From there I toured acts like the Beastie Boys and Beck. After those tours I developed a reputation and bands like Pearl Jam approached me. All I did was say yes.

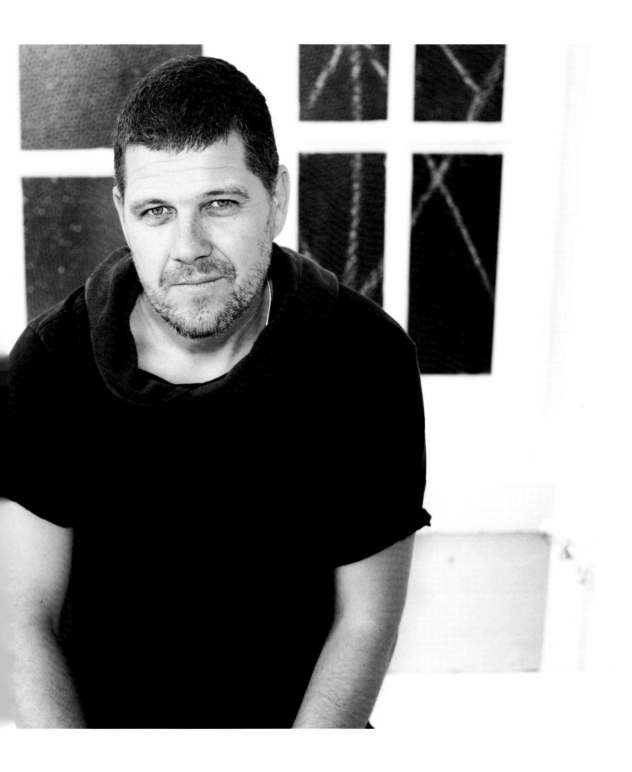

Similarly the opportunities to sign the Yeah Yeah Yeahs and The Presets presented themselves and I said yes. All in all I'm a really lucky person that knows the difference between no and yes in my chosen vocation.

*What are your greatest career achievements?*
From a personal point of view I'd say being able to do what I do each day and make a living from it. From an industry point of view I'd say the names of bands I've worked with.

*Now that the business is successful, what does your role consist of? Can you chill out more?*
These days my role consists of rolling in the sand with my daughter, drinking fresh, young coconut juice, cheering for the Carlton Football Club and expanding my culinary artillery.

*Where are you from? How long have you been in Bondi? Do you think you'll be there in the long-term?*
I grew up in Canberra and escaped to Sydney when I was 19. I've lived in the inner city / eastern suburbs since then and moved to Bondi in '88. After 20 odd years it's hard not to think of Bondi as home and it'll always be a special place for my family and me.

*What do you like about the area?*
When I first moved here it was a shit hole overrun by milk bars and hamburger joints. The water was dirty and during a good onshore the sewerage formed a noticeable slick just beyond the break. Rents were cheap and there was a real sense of community amongst the people I knew that lived here.

Most people I knew didn't want to come to Bondi and thought it was a dump and too far from the city. I loved that it polarised people and I loved that I could hang out at the beach all day whilst those

same people sweated it out in Surry Hills. There are not too many places in the world where you can be in the middle of a city and still be surrounded by so much nature. I love the fact that every day it gets a natural facelift and that on no two days does it look the same. It's a constantly evolving place and now most of the milk bars and hamburger joints have been replaced by hipster cafes. The rents are anything but cheap, the water is cleaner than I can ever remember and the only community I'm a part of is my immediate family.

*Living in Australia –does it have limitations in your industry?*
Yes and no. The world is a pretty small place these days and there's something exotic about being from Australia that people respond to.

*Would it be advantageous to live in a world capital such as New York or London?*
We have an office in New York and I've lived there for a couple of years. It's definitely important for us to have a presence over there but on another level I think the fact we're from Sydney is a plus for us and is a bit of a point of difference.

*Why do you think your artists are so successful, both locally and internationally?*
Because they write great songs. Music's a pretty universal medium and if the artist has something genuinely unique and special then there's no reason they shouldn't be successful locally and internationally, provided they're given the right platform. Which is where we come in...

*Is there an Australian sound – is Australian music discernable from other countries'?*
I don't think there's a particular sound as such; more just definable artists that come from here. Things like the Triffids or Nick Cave.

*Does our geographic location (at the far end of the earth) bear any influence on local music or does the interconnectedness of the world – advanced communications etc – negate this?*
In a way yes to both. I think artists often take influence from not just the US, but the UK, Europe, Asia and so on equally, and the music takes on its own mutant

shape. Being so isolated and far from any particular scenes that are going on, no matter how much you can listen to it on the internet and visualise it in your mind, the interpretation that comes out so far away will often be slightly skewed.

*What music did you listen to in the last 24 hours?*
The Pentagons, Unrelated Segments, Bag Raiders, Canyons, Wolfmother, Jonathan Boulet, Solid Gold.

*Your prediction for the next big Aussie music act?*
Jonathan Boulet.

**SASHA**

25

STYLIST

The hat I'm wearing I borrowed from friend; my boots, top and pants are all vintage; my bag is Balenciaga and jewellery is by Ksubi.

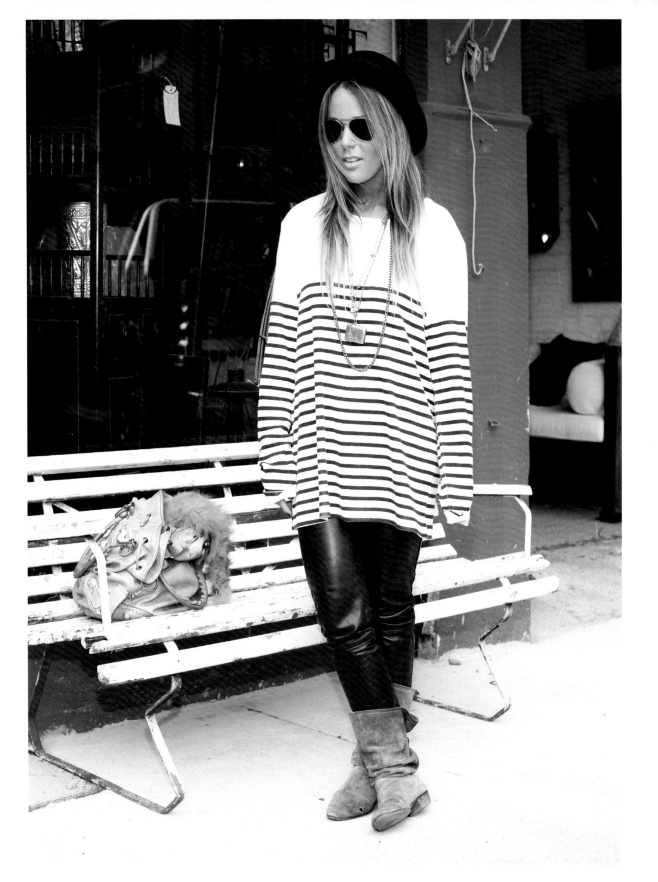

# ANGELIQUE MAY-BENNETT

## DESIGNER, MYPETSQUARE

Former model and long-term Bondi girl
Angelique May-Bennett, is half of the
design team behind cutting-edge label
MyPetsQuare.

*What are the signature traits of your
label?*
Offbeat; unconventional; unique shapes;
playing with ideas of retro styles; updating
bygone eras.

*You have cited really diverse sources of
inspiration – from early Brooke Shields
to the Eiffel Tower – what is inspiring you
currently?*
MyPetsQuare takes on tangents. The little
sQuare is akin to a young person who
isn't quite sure who they are yet and so
experiments constantly with new ideas;
crossing cultures and countries. Our latest
range, Ra Ra Rasputin, is inspired by all
things Russian – from vodka, Russian
ballet and old Europe to the newness of
Russian capitalism. This has resulted in
checks to give warmth, a black military
feel, baby flowers reminiscent of the
innocence of beautiful Russian countryside
peasants, as well as the coolest old Russian
cars that probably don't work and would
need their equivalent of the NRMA!

*What's coming up in your next collection?*
The collection has just been released
to stores and online and encompasses
perfectly easy little black dresses to be
layered and worn with long sleeves and
leggings underneath. There are delicious
ponchos, scarves and hoodies with ropes
attached as details. Our next range is
yet to be shown – a little hint is the
Andes musicians!

*What is it about the 70s era that you
love so much?*
It's the 70s, the 80s, the 90s and
sometimes the 50s. We kind of mash
everything together from what we love.
The 70s have special feelings for me as
it reminds me of comfort and flying to
visit my family in Holland. Something
about the launch of women's rights and
women's liberation as well... Vicki (co-
designer) and I love liberation in any
form! We seek to be free. The fun part

of freedom is when you first realise you have it! The 70s seem to link us to that beginning of freedom on many levels.

*How long have you lived in the Bondi area?*
I've lived at Bondi Beach since 1991. But actually, I spent most of that time keeping a house there as a base, coming home every eight months in between living in the States and all over Europe. I always came home though. I've been permanently living at Bondi for the last five years, not including a few overseas trips every year.

*On your website you mention the Bondi butchery- what else in Bondi inspires you?*
That was the old Bondi Butcher! It was a classic shot, the dog waiting for his cuttings. Unfortunately, it's no longer there. Just like most places, little quirky butchers and milk bars get replaced. It's an old photo from '96 that I took and have always loved.

I love the Icebergs Pool. The feelings of being there swimming and doing laps and showering afterwards have a beautiful simplicity to them that will never leave. I also love the new stores that have arrived, the little coffee shops that pop up and IKU Wholefoods. Yum.

The Beach Rd has many live bands playing and that's always fun when you don't want to wander further.

There's anything you want in Bondi, whether it's a fancy drink, or going herbal and doing yoga, or getting an O'Galo chicken wrap. They are my favourite and I have to watch how many I eat!

*What do you think is different in how people dress here compared with other parts of Australia, or other places overseas?*
The funny thing is that every time I would return from overseas, I would be shocked how Bondi is like a little country town, with hardly any people – that's how it seemed compared to overseas where the world seems so overpopulated. But when you live in Bondi you think it's always crowded, especially in summer! But it's truly not compared to New York, Hong Kong, London or any major city.

The next thing I would notice is that everyone seemed to be wearing such 'cool' clothes. Till I'd realise they were all wearing the same thing - ha! However, there is freedom to wear what you like; if you're different, then that's better. It's a casual cool, not a dressy fashion, like Paris. I remember when I lived in Paris, I'd be worried about walking to the shops in my tracksuits, because they all dress up so fancy, heels and all. It can be intimidating. Bondi has a cool edge that requires not too much effort involved. Too much effort is not cool in Bondi.

Compared to the rest of Australia, Bondi seems a little more professional than the northern parts of Australia, but not as done up as the southern parts of Australia.

*If you have friends in town from overseas, where do you take them locally? What is a 'must-see' or 'do'?*
The walks. The walk to Bronte; the walk to Watson's Bay. They show the cliffs and the ocean – the best part of Bondi is being right at the ocean. When it's raining, donning the overcoat and walking the sand on Bondi Beach is magnificent! The coffee at Luigi's and the little boutiques in the backstreets are great to visit. The Flying Squirrel tapas bar has a great atmosphere. Noodle King vegetarian laksa on a rainy day! See, I love the rainy days at Bondi Beach because the streets are empty. An amazing thing to do is dive off the cliffs at North Bondi – even though I'm a South Bondi girl.

There's a difference between North Bondi and South Bondi too – like the South of France, South Bondi is a bit more with it. The travellers that come to Bondi really add to the flavour, they offer unique taste buds and affect the social life of Bondi. I love running into an Irish person at the pub, or saving a Japanese person from the knee deep waves, or dodging a backpacker learning to surf. It's all part of what I love sharing.

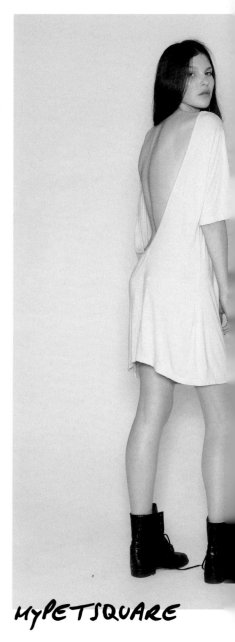

MyPETSQUARE

WHEN IT'S RAINING, DONNING THE OVERCOAT AND

WALKING THE SAND ON BONDI BEACH IS MAGNIFICENT!

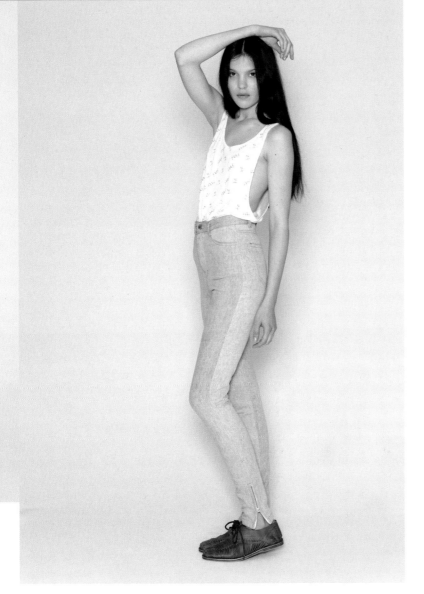

# OSCAR MARTIN & CHRIS WIRASINHA

## PEDESTRIAN

Gen-Y pop culture gurus Oscar Martin and Chris Wirasinha started their pioneering 'plastizine' named Pedestrian in 2005. Today, in addition to their production house, they bring Pedestrian devotees a daily dose of international goss from the fashion, music and celebrity worlds.

*What is Pedestrian?*
CW: Pedestrian is a DVD magazine (or plastizine), a website (www.pedestrian.tv), a daily newsfeed (Pedestrian Daily) and an advertising and content agency (Pedestrian Creative). The common theme is entertaining people.

OM: Pedestrian is cheeky, fun, informative and began to give exposure to creative people we liked, who weren't getting the recognition they deserved.

*How did you come up with the idea?*
CW: Back in the crazy summer of 2004, Oscar and I toyed with ideas to make it big like Branson via a TV show called Pedestrian.

OM: Pedestrian Plastizine (a DVD magazine) was a way to get our interviews out there immediately without having to convince a TV network that two kids in their very early 20s who had never filmed or edited anything, were worth investing in.

*What were you doing prior?*
CW: Given we were in our early 20s when we started out we didn't have time to do much else prior. We were both working in an advertising media agency, which is where we met.

*Pedestrian's really diverse in terms of the information you deliver... where do you source it from?*
CW: Pedestrian is the culmination of our collective interest in music, fashion, art and design. It's the bi-product of hundreds of hours spent trawling the net or flipping through magazines. Most of all it's sourced from simply looking around at the amazingly talented friends and people that surround us.

*What are its unique points/strengths within your field of online media?*
CW: We like to think that we're delivering up-to-date news on the characters influencing popular culture in a way that is cheeky, fun and irreverent. If you haven't signed up to our mail-out Pedestrian Daily you really should.

*How much do you live and breathe the Pedestrian lifestyle i.e. music, fashion, pop culture?*
CW: Knowledge, no matter how trivial, makes you a better person. So yes - read, listen, watch, collect, immerse and don't forget to breathe.

*Who have been some of the stand-out people you have interviewed over the years?*
CW: Dan Single from Ksubi for giving us our first break and an insight into their world. Joe Corre from Agent Provocateur for reminding us that you've got nothing to lose from picking up the phone. Miranda Kerr for gracing us with her ethereal beauty and breaking a story that ended up on the front page of the Daily Telegraph and hundreds of other papers around the world two years later.

*Do you have any off-the-wall stories you can share?*
CW: The best anecdotes are usually ones that you can't actually share but the ones that will keep you smiling when you're old and grey.

*Future plans?*
CW: We're currently working on a couple of television concepts, creating our own entertainment agency and launching a new website.

*You both live around the Bondi area... what makes you choose to live here?*
CW: Obviously the thousands of transient British backpackers and random discarded furniture strewn indiscriminately across nature strips. The beach, culture and restaurants are good too.

OM: The surf.

*Could you part with your best special locals' tips – places to go, things to do?*
CW: Eat at The Rum Diaries, Flying Squirrel, La Piadina, Ploy Thai and Jets. Go watch Australia's best bands play for free at the Beach Rd on Wednesday nights.

OM: Get takeaway hot roast beef or chicken schnitzel baguettes at Sun Café and head to "Make out Point" - North Bondi lookout.

*How would you describe Bondi style?*
CW: Not necessarily matching mine (you get strange looks if you go to the beach wearing a suit). Vintage for the girls and beards, fedoras and vests for the boys.

*What changes to the area do you foresee in the coming years?*
OM: More sharks!

CW: Hopefully everyone in the world watched An Inconvenient Truth and treats the environment nicely so my second floor apartment doesn't become a waterfront.

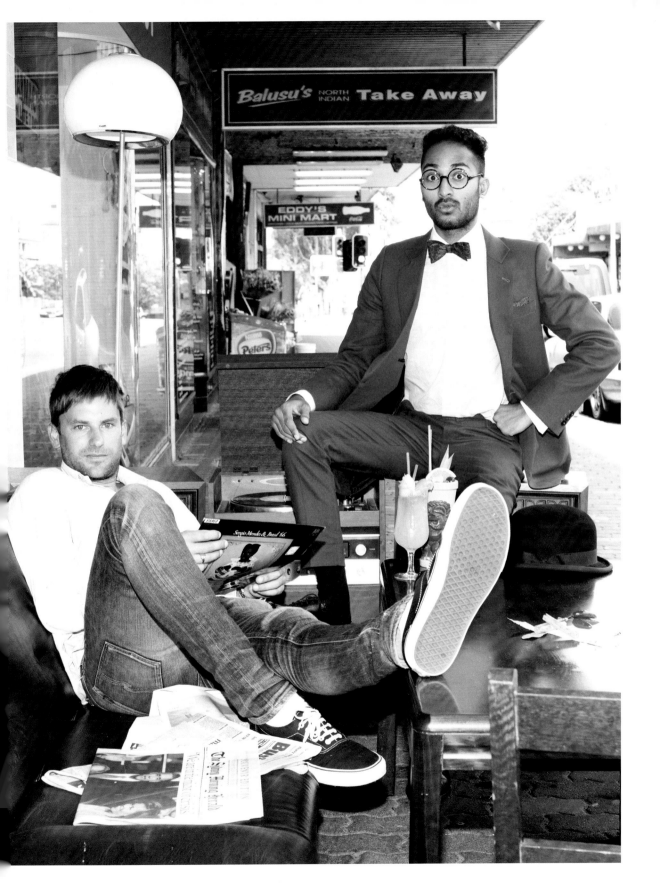

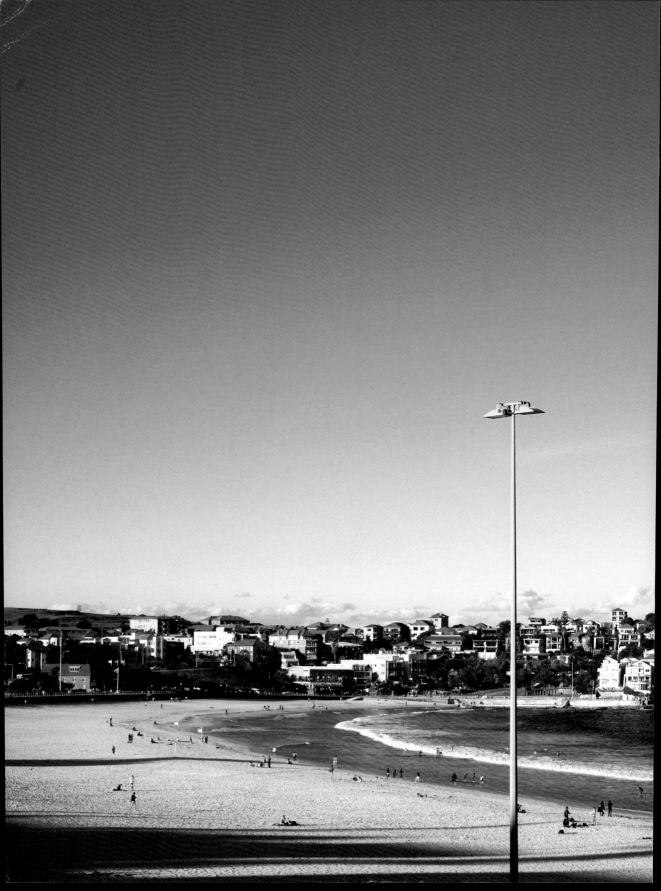

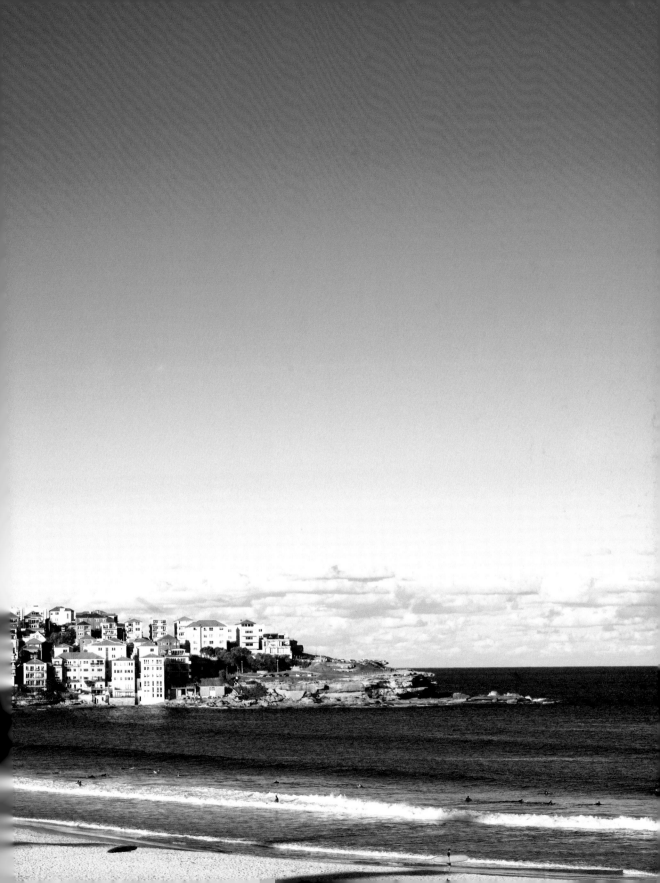

# COMPENDIUM

## RETAIL

Tuchuzy
*90 Gould St*
*T 9365 5371*
*W tuchuzymag.blogspot.com*

The Market
*2 Jacques Ave*
*T 9365 1315*

Purl Harbour
*2/2 Jacques Ave*
*T 9365 1521*
*W purlharbour.com.au*

Ksubi
*82 Gould St*
*T 9300 8233*
*W ksubi.com*

Jatali
*Shop 4, 87 Gould St*
*T 9365 2066*

Camilla
*132A Warners Ave*
*T 9130 1430*
*W camilla.com.au*

Aquabumps Gallery
*151 Curlewis St*
*T 9130 7788*
*W aquabumps.com*

Mish Mash
*11 Curlewis St*
*T 9130 8395*
*W ourmishmash.com*

## CAFES/BARS/RESTAURANTS

North Bondi Italian Food
*118 Ramsgate Ave*
*T 9300 4400*
*W idrb.com*

Sean's Panaroma
*270 Campbell Parade*
*T 9365 4924*
*W seanspanaroma.com.au*

Gertrude & Alice
*46 Hall St*
*T 9130 5155*
*W gertrudeandalice.com.au*

The Shop & Wine Bar
*78 Curlewis St*
*T 9365 2600*

Icebergs Dining Room & Bar
*1 Notts Ave*
*T 9365 9000*
*W idrb.com*

Flying Squirrel
*249 Bondi Rd*
*T 9130 1033*
*W flyingsquirreltapasparlour.com.au*

Greens Café
*140 Glenayr Ave*
*T 9130 6181*

Rum Diaries
*288 Bondi Rd*
*T 9300 0440*
*W therumdiaries.com.au*

Raw Bar
*Shop 1, 136 Warners Ave*
*T 9365 7200*

Deli Bottega
*Shop 1, 144 Glenayr Ave*
*T 9365 7319*

Luigi's
*Shop 17, 154 Glenayr Ave*
*T 9365 7333*

Bru
*4/101 Brighton Blvd*
*T 0401 496 631*

Earth Food Store
*81A Gould St*
*T 9365 5098*

Roy's Seafood & Tapas
*141 Curlewis St*
*T 0450 955 987*

La Piadina
*106 Glenayr Ave*
*T 9300 0160*

Harry's Espresso Bar
*Shop 2, 136 Wairoa Avenue*
*T 9130 2180*
*W harrysespressobar.com*

## FASHION LABELS

Fernando Frisoni
*fernandofrisoni.com*

MyPetSquare
*mypetsquare.com*

Cassette Society
*thecassettesociety.com.au*

Graz Sunglasses
*grazmulcahy.com*

Hotel Bondi Swim
*hotelbondiswim.com.au*

Ellery
*elleryland.com*

Josh Goot
*joshgoot.com*

Camilla & Marc
*camillaandmarc.com*

Sass n Bide
*sassandbide.com*

Willow
*willowltd.com*

Illionaire
*illionaire.com.au*

Luci in the Sky
*luciinthesky.com*

Shakuhachi
*shakuhachi.net.au*

Kirrily Johnston
*kirrilyjohnston.com*

Darko
*darkolabel.com*

Ruby Smallbone
*rubysmallbone.com.au*

Matt Weston
*mattwestonjewellery.com*

Nathan Smith
*thisisnathansmith.com*

Chronicles of Never
*chroniclesofnever.com*

Romance Was Born
*romancewasborn.com*

Bassike
*bassike.com*

Nicola Finetti
*nicolafinetti.com*

## OTHER

Modular Records
*modularpeople.com*

Sneaky Sound System
*sneakysoundsystem.com*

Pedestrian
*pedestrian.tv*

Stab Magazine
*stabmag.com*

Bondi markets
*(Sundays)*
*Bondi Beach Public School,*
*Campbell Parade opp. beach*
*bondimarkets.com.au*

## ACKNOWLEDGEMENTS

Special thanks to:
Radan Sturm
Ashley Gorringe
Sarah Wilson
Elli Bobrovizki
Megan Mair
Tessa Bautovich

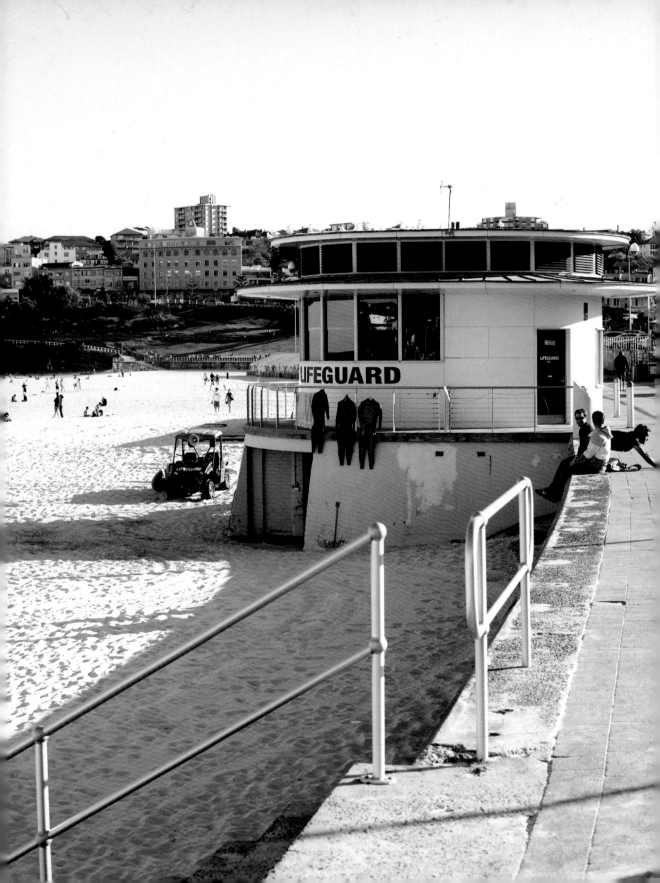